A–Z

OF

LINCOLN

PLACES - PEOPLE - HISTORY

Wendy Turner

AMBERLEY

To my dearest family and friends, past and present and new friendships made in Lincoln.

There's an isolated, desolated spot I'd like to mention, where all you hear is 'stand at ease', 'quick-march', 'slope arms', 'attention'. It's miles from anywhere, by Jove it's a rum 'un. A man lived there for fifty years and never saw a woman.

(A cheeky lament on the remoteness of RAF Cranwell, penned in 1916.)

First published 2023

Amberley Publishing
The Hill, Stroud, Gloucestershire, GL5 4EP
www.amberley-books.com

Copyright © Wendy Turner, 2023

The right of Wendy Turner to be identified as the Author of this work has been asserted in accordance with the Copyrights, Designs and Patents Act 1988.

ISBN 978 1 3981 0010 7 (print)
ISBN 978 1 3981 0011 4 (ebook)

British Library Cataloguing in Publication Data. A catalogue record for this book is available from the British Library.

Typesetting by SJmagic DESIGN SERVICES, India. Printed in Great Britain.

Contents

Introduction

The cathedral city of Lincoln offers a unique history dating from the first-century BC settlement of Lindon/Lindum, *Lindo* (the Pool). The many faces of Lincoln are yours to explore, from Steep Hill leading to the 'Uphill' Cathedral Quarter with its beautiful cathedral dating from 1072, and the historic castle with its Medieval Wall Walk and precious original Magna Carta. The Stonebow and Guildhall invite you to step back in time and explore treasures and artefacts from sieges, battles and celebrations through the centuries. You can also follow Lincoln's links to blockbuster films such as *Lawrence of Arabia, The Da Vinci Code* and *The Dam Busters*.

Yet Lincoln has a darker side, including the castle's grim prison history and chilling tales of lonely tombstones and remembrances of the hapless inmates. Sieges and bloody battles of kings and would-be kings are yours to relive, along with their legacies of priceless artefacts, swords, charters and insignia.

Lincoln invites you to a feast of stunning architecture, ghostly tales, the arts, Lincolnshire wool and cloth and even its famous Lincolnshire sausages!

Walk with heroes and villains, the bizarre and mysterious through the ages as you discover history on your doorstep. Whatever your interest, Lincoln is the place to delve into thousands of years of 'Places, People and History'.

Arboretum

A water cascade system once flowed through Lincoln's Temple Gardens but when it closed in 1863, the city council created a new botanical park, the Arboretum. It was designed by renowned Victorian landscape gardener Edward Milner and opened in 1872. The 1911 fountain celebrated Lincoln's new water supply.

The Arboretum covers 22 acres of parkland on land originally part of the eleventh-century Benedictine priory of St Mary Magdalene. It has a wide variety of trees and shrubs, gardens and flower beds, grasses, ornamental ponds and a children's play area. Botanical gardens are used for education and research as well as the pleasure of spending time in off-the-track and beautiful surroundings.

The Arboretum Terrace is around 300 m long and is a central feature of the park. A stroll over the gently sloping hillsides and along the stone steps takes you past the handsome Grade II listed cast-iron bandstand and shelter, ponds fringed with

Lincoln Arboretum. (Photo Wendy Turner)

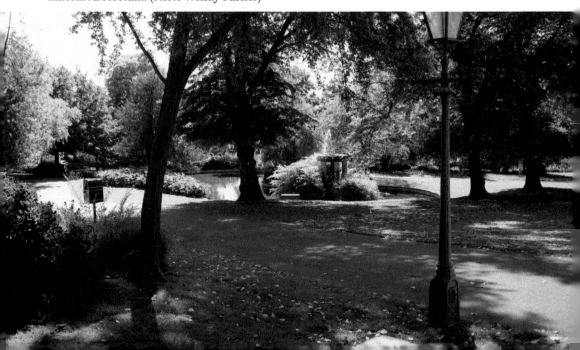

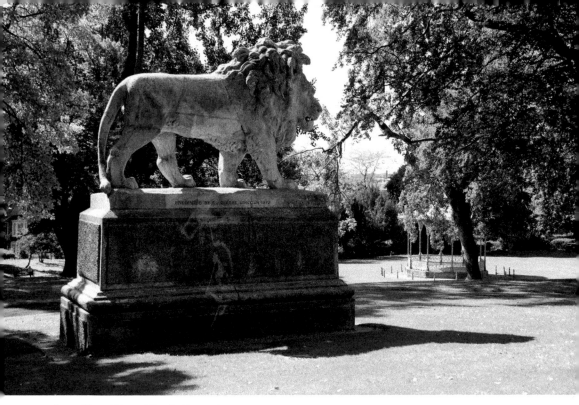

Stone lion. (Photo Wendy Turner)

willows, ornamental bridges and the larger-than-life stone lion, presented to the city in 1872 by the mayor, F. J. Clarke JP. You can look up to the surrounding grand Victorian houses or, at the top, enjoy wonderful views over the city.

Edward Milner also designed the Pavilion Gardens in Buxton, Derbyshire, where his name is emblazoned on the little steam locomotive that runs on the miniature railway.

Lincoln's Arboretum is the city's main open green space, owned and managed by the City of Lincoln Council.

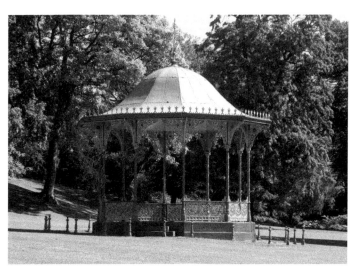

Bandstand. (Photo Wendy Turner)

Aviation – Alex Henshaw MBE

Educated at Lincoln Grammar School in the 1920s, Alex Henshaw soon developed an unbridled passion for flying. He longed to spread his wings further afield and tackled competitions and races across Europe. After winning the inaugural London to Isle of Man air race in 1937 in terrible weather, he turned his attention to the coveted King's Cup, regarded as the zenith of amateur flying. Alex achieved this in 1938 in his specially adapted tiny Percival Mew Gull aircraft with an average speed of 236.25 mph.

The following year presented him with a far greater challenge, a long-distance solo record return flight to Cape Town. He took off from Gravesend on Sunday 5 February at 03:35 GMT in his Mew Gull. Stopping only to refuel, he landed in Cape Town after flying 6,030 miles in just under forty hours. Spending only twenty-eight hours in Cape Town, he reversed the route home and landed at Gravesend on 9 February – four days, ten hours and sixteen minutes after leaving.

Alex broke the record for each leg of the flight, setting a solo record for the whole trip. It was reported that he was so exhausted on landing back in the UK that he had to be lifted out of the cockpit. The story was published in *The Telegraph* in 2007 and told in Alex's book *Flight of the Mew Gull*.

During the Second World War, Alex became a test pilot flying Spitfires and Lancaster Bombers. His aircraft G-AEXF is now in the Shuttleworth Collection, Old Warden. He died in 2007 at the age of ninety-four.

His father's sage advice stood Alex in good stead: 'I think you had better wear a parachute, my boy.'

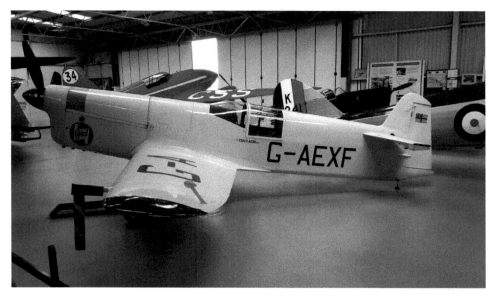

Henshaw's Percival Mew Gull. (By kind permission of the Shuttleworth Collection. Photo Ray Wilkinson)

B

Beach

Lincoln's 'pop-up beach' started life as 'Lincoln by the Sea' in 2011 and has blossomed year on year under Lincoln Business Improvement Group (BIG). The idea is that, as many families are unable to take time out to go to the beach, the beach could come to Lincoln's city centre! Lincoln BIG supplies deckchairs and buckets and spades. Sand comes from Huttoft, between Mablethorpe and Skegness, and is returned at the end of each summer.

Lincoln beach offers children hours of fun on the 'seashore'. They can also watch the antics of Punch and Judy while enjoying snacks or lunch from local shops and kiosks.

Lincoln beach is an annual event 'live' from mid-July until the end of August. It has been a BIG success for the last nine years or so and hopefully for many more to come.

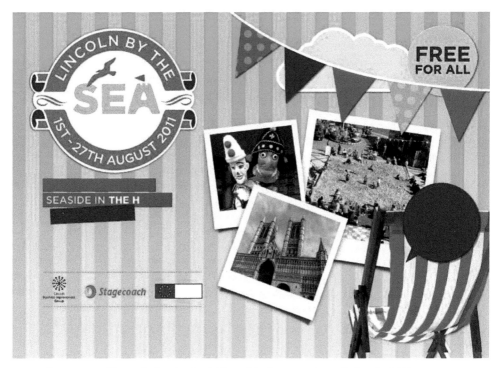

First advertising of 'Lincoln by the Sea'. (© By kind permission of Lincoln BIG)

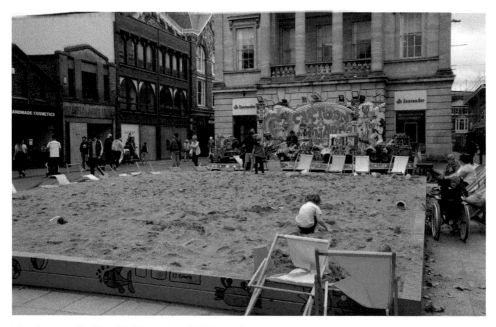

Playtime on the 'beach'. (Photo Ray Wilkinson)

Bell

Ships' bells have had many traditional and symbolic uses through the centuries. The brass bell of HMS *Lincoln* was used as a font for christenings held at sea for children of the crew. The bell was upturned and filled with water for the ceremony and the name of the child and date of christening inscribed on the inside. HMS *Lincoln*'s bell is among many treasures kept at the Guildhall.

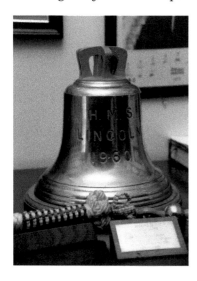

Bell. HMS *Lincoln*. (By kind permission of City of Lincoln Council. Photo Ray Wilkinson)

The Bishop v the Baronet

In 1775 Lord of the Manor Sir Lionel Lyde built himself a Georgian red-brick mansion at Ayot St Lawrence, Hertfordshire, but he considered the nearby twelfth-century picturesque church to be a blot on his landscape. He set about tearing it down but it came to the ears of the Bishop of Lincoln, in whose diocese the church stood. Fury raged as the Bishop lectured the Baronet on his obligation to build a new church. Somewhat cornered, Sir Lionel built a huge new church in the neoclassical style in the middle of a field with an uninterrupted view from his mansion.

Sir Lionel's marriage was a turbulent one. When building his new church, he arranged for separate commemorative urns for himself and his wife on opposite sides of the grand frontage. His will makes his feelings abundantly clear: 'who the church has joined together in life, may it keep separate in death'. His neoclassical church remains the parish church of Ayot St Lawrence.

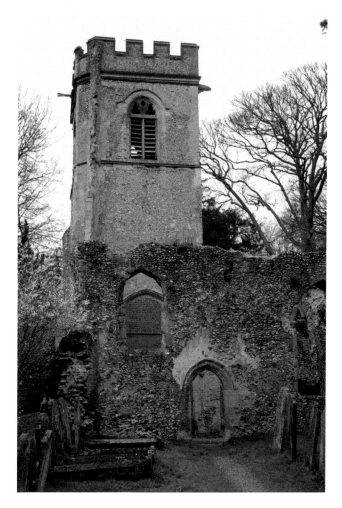

Ruins of old church, Ayot St Lawrence. (Photo Wendy Turner)

11

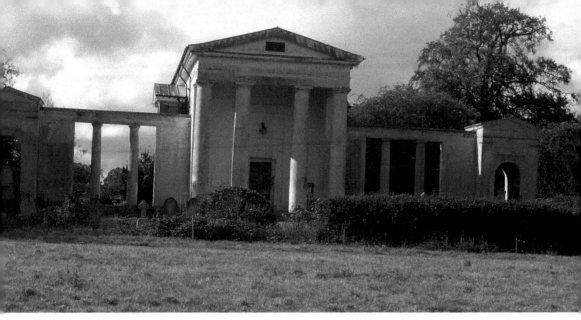
New neoclassical church, Ayot St Lawrence. (Photo Ray Wilkinson)

Bishop's Eye Window

To stand at the crossing in Lincoln Cathedral and gaze up at the 'Bishop's Eye' window, one of the two 'Rose' windows, is to turn back the centuries to the 1220s when it was made, although it was rebuilt a hundred years later. The elegant window shows two adjacent veined leaves with fragments of thirteenth- and fourteenth-century stained glass. The Bishop's Eye sits over the south door overlooking the ruins of the old Bishop's palace and south towards the sun, interpreted as embracing God's light and love. The palace is now in the care of English Heritage (*see* Cathedral).

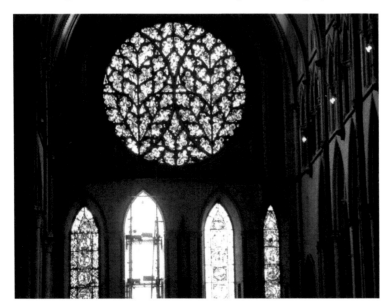
Bishop's Eye Window, Lincoln Cathedral. (By kind permission of Lincoln Cathedral. Photo Wendy Turner)

George Boole (1815–64) and 'Boolean Logic'

George Boole first learnt mathematics as a young child at his father's knee but later in life he became a self-taught genius in all things mathematical. By his mid-teens he was teaching in village schools and by the age of twenty he was running his own school in Lincoln at 3 Pottergate, near the cathedral.

George was an avid reader of the mathematical journals in Lincoln's Mechanics Institute, of which his father was a founder, and was soon submitting papers to major journals. In 1844 he was awarded the Royal Society's first Gold Medal for Mathematics for his paper on the Philosophical Transactions of the Royal Society. 'Natural Philosophy' at the time included such topics as astronomy and optics. In 1847 George published his major work, *Mathematical Analysis of Logic*, and two years later took up the first Professorship of Mathematics at Queen's College Cork (now University College Cork). It was here that George met his wife, Mary Everest, a renowned mathematical psychologist whose work encompassed understanding how children learned maths and science. They had five daughters, the youngest only six months old when George contracted pneumonia and died at the age of forty-nine (*see* Mount Everest and Mary Everest Boole).

George's groundbreaking work was recognised by American mathematician and electrical engineer Claude E. Shannon (1916–2001) in his work *A Symbolic Analysis of Relay and Switching Circuits*. It was also acknowledged by British mathematician Alan Turing, famed for cracking the Enigma Code at Bletchley Park during the Second World War which paved the way for Allied victory over Nazi Germany.

George Boole proved to be one of Lincoln's greatest thinkers and is famed for his Boolean Logic, which forms the basis of today's digital computer circuits and programming. His memory is preserved in Lincoln Cathedral in the stained-glass

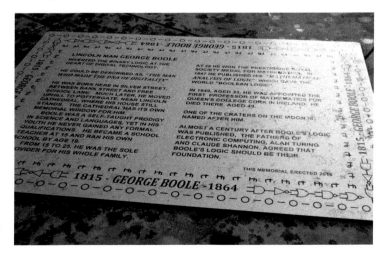

Boole plaque. (Photo Wendy Turner)

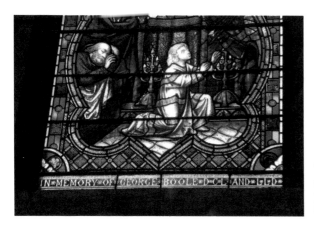

Teaching Window, Lincoln Cathedral. (By kind permission of Lincoln Cathedral. Photo Wendy Turner)

Teaching Window, funded by Friends of Boole which, at Mary's request, depicts *The Calling of Samuel*, George's favourite Biblical passage.

George Boole joins other eminent scientists, explorers and astronauts in having a crater on the moon named after him.

Brayford Water Chimes

This eye-catching rotating water clock in the heart of Lincoln overlooks the Brayford Pool. It was designed to operate by flow of water through copper water bowls which are released to strike the hour. The top rotates hourly and at night the base is illuminated by a light beam showing the time. The sculpture was commissioned by Lincoln City Council and installed in December 2001.

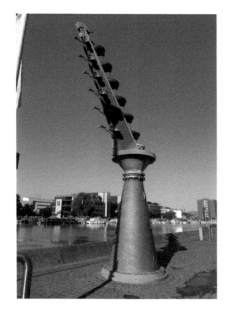

Brayford Water Chimes. (Andy Plant. Photo Wendy Turner)

C

Castle and the Medieval Wall Walk

In August 1541 Henry VIII, resplendent in green velvet, and his fifth wife, Catherine Howard, resplendent in crimson velvet, rode into Lincoln amid great fanfare. After being welcomed by the mayor and attending a service in the cathedral, William Colbourne, a herald, noted 'His Grace rode at afternoon to the Castle and did view it, and the City.'

Monarchs, soldiers and rebels have built, lived in and fought over Lincoln Castle since Roman times when a timber fortress was established on the hilltop. In 1068 William the Conqueror ordered a motte-and-bailey castle to be built under the jurisdiction of

Lincoln Castle. (Photo Ray Wilkinson)

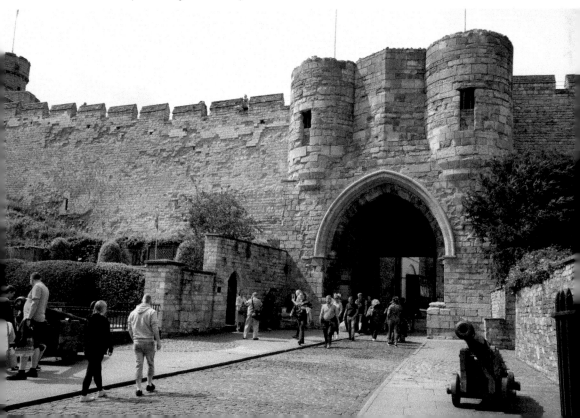

the Norman Bishop Remigius. That too was built of wood, then rebuilt some fifty or so years later in stone when it burnt down. The castle strengthened William's hand in controlling the north. It was also a clear message to the people, seemingly from the top of the world, that the Normans were firmly in charge of Lincoln.

The main entrance is the grand East Gate at the top of Steep Hill, flanked by a pair of matching cannon dating from 1721 and once used by the Navy on their ships. They then stood at a brewery gate for some time until moved to the castle in 1980.

The magnificent Medieval Wall Walk, completed by the Lincoln Castle Revealed Project, offers panoramic views over Lincoln and takes you past Cobb Hall, the Lucy Tower and the Observatory Tower.

Cobb Hall (probably so named because of 'cobbs', stone cannonballs discovered there) was built in the 1230s and likely used for both formal and military purposes. Iron rings testify to its later reuse as a lock-up for drunkards. In the nineteenth century it was reused for executions when a grim, temporary gallows was set up on the roof. The last execution occurred in 1859.

The Lucy Tower, *turris Luce*, is a 'shell keep', a round, stone defensive enclosure built at the top of a motte (mound). It was named for Countess Lucy Taillebois, a powerful and wealthy woman (*c.* 1067–1138) who married the Sheriff of Lincoln by order of her overlord, the King. On the death of the Sheriff, Lucy was strategically married twice more and, by her marriage to her third husband, Ranulf le Meschin, became Countess

Lincoln Castle at night. (Photo Wendy Turner)

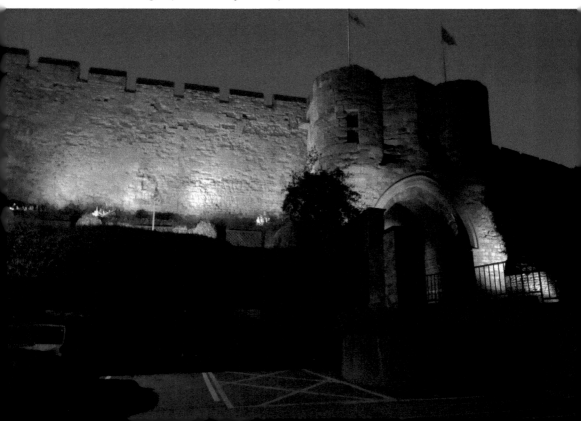

of Chester. On his death and then aged around sixty, Lucy purchased the right never to marry again by gladly paying King Henry I 500 marks!

The Lucy Tower became used for the burial of unfortunate executed prisoners and prisoners who had died. Today, their tombstones remain a quiet testament to their memory (*see* Prison).

Prison governors kept a sharp eye open for escapees from the mid-twelfth century Observatory Tower but Governor John Merryweather (1768–1862) extended it upwards to better accommodate his passion for observing the night sky.

The castle was besieged by Parliamentary forces during the Civil War but in 1660 and at the Restoration of Charles II, the castle's military history came to an end and it became a powerful centre of government and justice. The Crown Court still sits in the nineteenth-century assize court building. The bailey – the inner grounds and now beautiful gardens – is a well-loved and well-used space for events ranging from ceremonial and jousting to Lincoln's Sausage Festival and its famous illuminated Christmas Market, all held in the shadow of the glorious cathedral.

A precious copy of Magna Carta, one of only four of the 1215 issue, is housed and displayed in its own specially designed chamber next to the one-time Victorian prison (*see* Magna Carta).

Cathedral

MP and Journalist William Cobbett wrote in 1830:

> Lincoln Cathedral is the finest building in the whole world. To the task of describing a thousandth part of its striking beauties I am inadequate; it surpasses greatly all that I had anticipated.

The Cathedral Church of the Blessed Virgin Mary of Lincoln stands in majesty seemingly on top of the world, within the bounds of the old Roman City of *Lindum Colonia*. It serves as a place of worship and prayer and offers study and learning. The cathedral is also a centre for creativity, art and music, a destination for vast numbers of pilgrims and visitors and, in its more recent history, became a unique landmark for aircraft reconnaissance during the First and Second World wars (*see* IBCC). Together with the castle, these two historic buildings have stood tall on the horizon, symbols of Church and State, love and war and peace and power through the centuries.

Bishop Remigius instigated the building of the cathedral at the command of William the Conqueror in 1072 but he died twenty years later, just before its inauguration. The cathedral withstood the onslaught of a great fire, *c.* 1124, and a severe earthquake in 1185 which left only the West Front and its twin towers intact. A year later Hugh of Avalon, a French Carthusian monk, was appointed Bishop of Lincoln. He became venerated as St Hugh and was instrumental in rebuilding and extending the existing

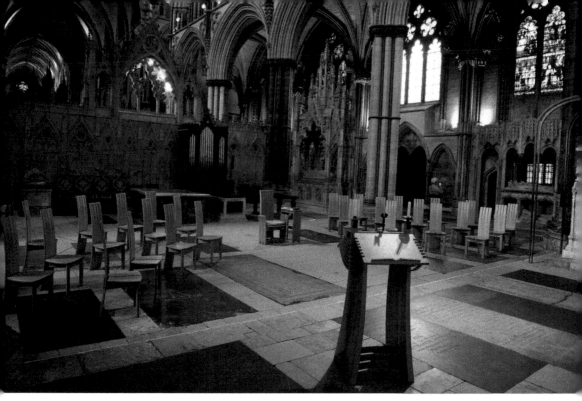

Lincoln Cathedral. (By kind permission of Lincoln Cathedral. Photo Ray Wilkinson)

Norman cathedral in the new and elegant Gothic style (*see* St Hugh and the Swan). Local people are believed to have contributed towards the building work, not least the famous Swineherd of Stow. You can see him blowing his horn on the north-west turret of the cathedral. His generosity is celebrated in Thomas Cooper's 1846 poem:

> He offereth his horn at our Lady's hymn
> With bright silver pennies filled up to the brim

Further damage occurred when the Central Tower collapsed in 1237. A new tower and spire were completed by 1311, extending the cathedral to the dizzying height of 160 m. Lincoln Cathedral was then considered the world's tallest building, a reputation that lasted over 230 years until a great storm in 1548 damaged the Central Tower spire. The cathedral has suffered further damage over the centuries, not least by Cromwell's forces in 1644 in their siege of Lincoln during the English Civil War.

As noted by William Cobbett, the cathedral is a place of spectacular beauty and a place for quiet reflection and meditation, no more so than at the Gilbert Pots. These giant pottery candlesticks and bowls are dedicated to the Lincolnshire monk Gilbert of Sempringham (1083–1189), founder of the Gilbertine Order. During his long lifetime of 106 years, Gilbert championed education for both girls and boys and built a number of monasteries together with places of refuge for the sick and needy, outcasts and lepers. Miracles were ascribed to him both during his lifetime and after his death. Such was Gilbert's fame that his tomb was visited by King John in 1201. Gilbert's Feast

Right: Swineherd of Stow. (Photo Wendy Turner)

Below: Gilbert Pots. (By kind permission of Lincoln Cathedral. Photo Ray Wilkinson)

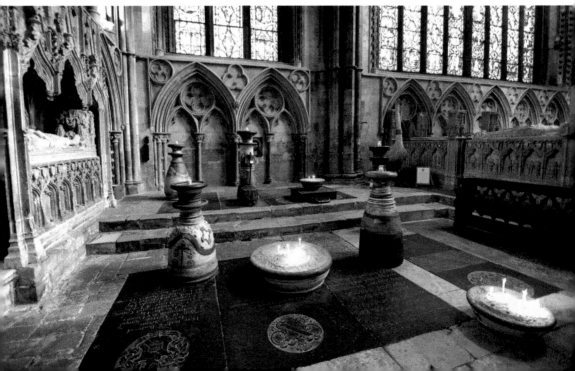

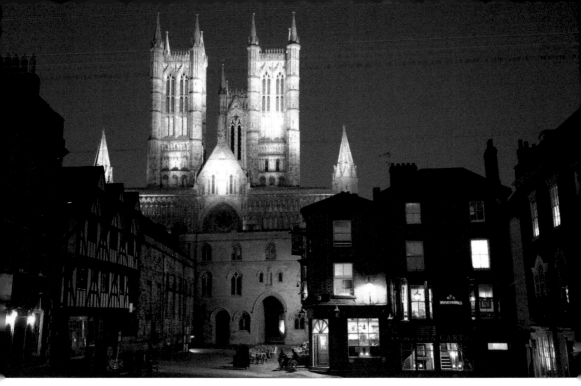

Lincoln Cathedral at night. (Photo Ray Wilkinson)

Day is celebrated on 4 February, the anniversary of his death. The Gilbert Pots were a commission for the cathedral in 1985 and created by the late artist Robin Welch in the 1990s. Visitors are invited to light a candle and spend time in the stillness of the cathedral, near St Hugh's Shrine.

The Christian theme of *Fight the Good Fight* is depicted on the sides of the twelfth-century Flemish Tournai marble baptismal font, with mythical beasts of good and evil in combat.

In 2005 the Chapter House was the venue for shooting the final scenes of *The Da Vinci Code* and in 2007 filming for *The Young Victoria* took place in the cathedral.

Lincoln Cathedral is one of the UK's most significant medieval buildings and a tribute to the master masons and technology of the time. Heritage Lottery Funding was recently allocated to the cathedral for essential restoration and renovation works, including the creation of new visitor facilities.

The cathedral was voted the country's favourite cathedral on Twitter's light-hearted poll 'Cathedral World Cup' in 2017.

Chaucer (*c.* 1345–1400)

Geoffrey Chaucer was the son of a London wine merchant. He married Philippa de Roet, sister of Katherine Swynford, third wife of John of Gaunt, Duke of Lancaster. Katherine lived on Pottergate near the cathedral (*see* Katherine Swynford). Philippa was also a lady-in-waiting to Constanza of Castile, John of Gaunt's second wife.

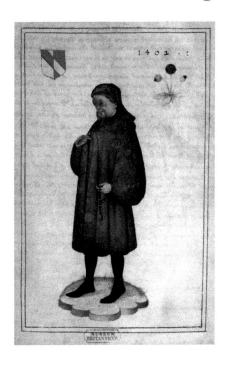

Geoffrey Chaucer. (British Library)

Chaucer started life as a page, serving the nobility and mixing with influential men and women. With a rapidly developing talent for writing he began composing poems, one of the earliest of which was *The Book of the Duchess*. It was written *c.* 1369 for John of Gaunt and read out at the anniversary of the death of his first wife, the beautiful Blanche of Lancaster who died from bubonic plague. The Black Knight mourning his love in Chaucer's poem is believed to be John of Gaunt himself.

Chaucer is best remembered for his *Canterbury Tales*. Young Hugh of Lincoln appears in *The Prioress's Tale* where he is murdered by 'guilty Jews' (a reflection of the times) and his body thrown into a pit. The dead child continues singing to the Virgin Mary until the Abbot turns up and solves everything. A copy of *Canterbury Tales* from the fifteenth century is a treasured possession in Lincoln Cathedral's Medieval Library. It was one of around 4,000 books and manuscripts given to the cathedral by Dean Michael Honywood who arrived in Lincoln in 1660, the first Dean at Lincoln after the Civil War.

The Collection – Art and Archaeology in Lincolnshire

You can take in Lincolnshire's diverse heritage and delve into its ancient and natural history at The Collection following the trail from the Stone Age to the present day.

The Collection, a sister museum of the Usher Gallery, moved to its new home on Danes Terrace in 2005. It was previously known as The City and County Museum,

founded in 1906 and housed in The Greyfriars, an exquisite thirteenth-century Franciscan church on Broadgate. Its curator was the dynamic Arthur Smith. Born in 1869, he worked in the boot and shoe industry in Grimsby but developed a lifelong passion for natural history and joined relevant fellowships and societies. His work was crowned with success when he was offered the post of Curator of the Museum and he soon found himself in Lincoln with his wife and two small sons.

Arthur set about collecting and coordinating over 12,000 local natural history specimens, archaeological artefacts, objects from world cultures and decorative art. Collections and memorabilia were also donated, not least from Lincoln Cathedral and Lincoln Mechanics Institute. On moving to its new purpose-built home and with its new name, The Collection held over two million objects, including the huge Iron Age Fiskerton Log Boat discovered on the banks of the River Witham near Fiskerton and hewn from a single oak.

Cow Paddle Common

This long narrow common lies between Washingborough Road in the south and the railway line in the north and is one of three large commons within the city. Its strange sixteenth-century name lingers on from the time when much of the marshy area was used for grazing livestock in the meadows and grasslands and cows 'paddled' in water. Today, the common is a natural open space for walking, horse-riding, exercising and spotting wildlife with spectacular views of historic Lincoln Cathedral.

Cow Paddle Common. (Photo Ray Wilkinson)

D

Dean's Eye Window

You can best view the other Rose window, the Dean's Eye, from the crossing in the cathedral. The window, installed *c.* 1220s, is considered an outstanding example of early English plate tracery and contains most of the original stained glass. The composition is of the second coming of Christ and the Last Judgement with the Blessed in Heaven gathered around Christ in Majesty. A sixteen-year programme of restoration was completed in 2006 when the stone tracery was re-carved and conservation of the glass carried out.

The Dean's Eye window stands in silent beauty on the north side of the cathedral overlooking the Dean's residence, and interpreted as keeping out the devil's deeds (*see* Cathedral).

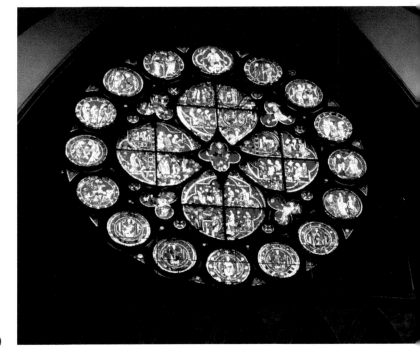

Dean's Eye Window,
Lincoln Cathedral.
(By kind permission
of Lincoln Cathedral.
Photo Wendy Turner)

Dean's wife. (Photo Ray Wilkinson)

Dean's Wife

High on a wall opposite the Deanery, a carved head keeps watch. It's said to be the Dean's wife, her eagle eye searching for her husband lest he call in at the Swan public house on his way home!

Dog – Snips (1946–61)

Snips, a Sealyham terrier, could be said to be Lincoln's pet. His owner, Henry Tyler, a market trader, took Snips with him to work. The little dog soon became the centre of attention when passers-by and children stopped to give him a pat. Henry was quick to recognise a fundraising opportunity and began charging a penny per pat. As the months went by and the pennies turned to pounds, Snips became the most petted pet in Lincoln and throughout the 1950s, thousands of pounds was raised for local charities with special efforts being made during emergencies. His pennies also helped to pay for an annual afternoon tea party for Lincoln's seniors.

Snips was a popular guest at many functions and was awarded several medals presented by Lincoln's civic leaders. He died in 1961 at the age of fifteen and his little body lay in state on Cornhill. His photo, collar and medals were presented to the City and are displayed with the city's treasures in the Guildhall. Snips' collar is inscribed with details of special fundraising emergencies and a plaque in the Cosy Club in the Cornhill area of the city honours his happy story.

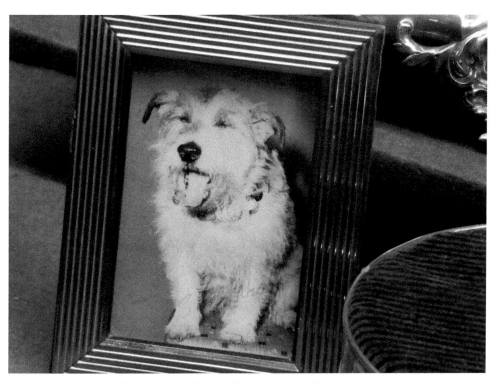

Snips the dog. (By kind permission of City of Lincoln Council)

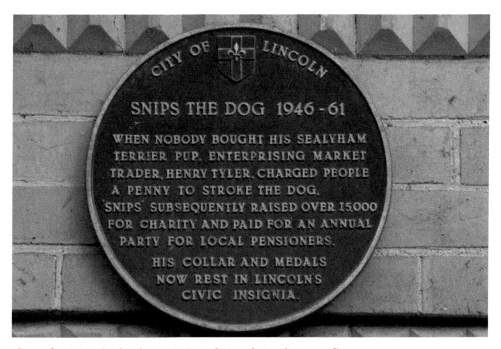

Plaque for Snips. (By kind permission of City of Lincoln Council)

Embroiderers' Guild

The Lincolnshire branch of the Embroiderers' Guild was formed in 1956. It is based in Lincoln but draws members from a large area and, with sister branches in Grantham and Boston, covers much of the county. Some branch projects have focussed on special events such as the First World War commemorative piece and the Magna Carta celebrations. Members have also contributed to national projects and competitions. The branch has good links with the cathedral where it has had a number of exhibitions in the beautiful setting of the Chapter House. An exhibition had been planned to celebrate the Branch's sixty-fifth anniversary but, due to the

1914–1918 In Stitch. (By kind permission of the Lincolnshire Embroiderers' Guild. Photo Ray Wilkinson)

Covid-19 pandemic, is planned to take place at a later date. The pandemic has also highlighted the importance of the guild's art to mental health and companionship and has challenged them to find new ways to share their learning and interest and promote the textile arts. (emreg.org.uk)

Empowerment

This aluminium and steel sculpture was erected in 2002. Two giant human figures reach towards each other from either side of the waterside. The artwork is inspired by the form of turbine blades and stands 16 m tall at the highest point. The message is one of mutual empowerment.

The artist, Stephen Broadbent, aimed to create a bold and striking sculpture for the Millennium. The design for *Empowerment* sprang into being following a visit to the Alstom Engineering factory in Lincoln. The pattern was then made in his workshop, cast in aluminium and welded together.

Stephen starts each work with a voyage of discovery into local worthy stories, large or small and whether current or hidden in the mists of time. The theme is then developed and the resulting designs discussed with planners, architects, engineers and the local community.

Empowerment creates a sense of place in the heart of Lincoln. It is a celebration of the city, its citizens and Lincoln's traditional and engineering industries.

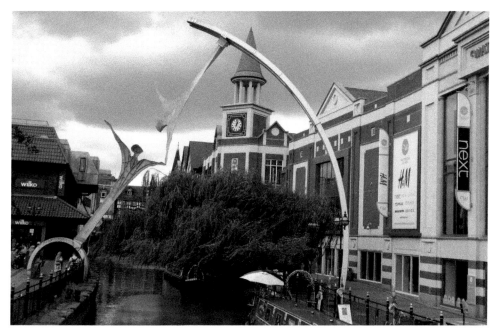

Empowerment. (Stephen Broadbent. Photo Wendy Turner)

The Executioner

Lincolnshire cobbler William Marwood (1820–83) did much more than repair worn-out soles; he dispatched many souls by way of his second job, official Public Executioner! Throughout his career, Marwood travelled the length and breadth of the British Isles to hang 171 men and eight women.

Although perhaps somewhat macabre, Marwood took a keen interest in improving execution methods. He perfected his 'long drop' method which took into account the unfortunate person's weight and the drop required to speed up the process and cause minimum distress.

In 1872 the first man executed by Marwood was pub landlord William Horry who shot his wife in a drunken rage. The Governor of Lincoln prison, impressed by Marwood's skills, gave permission for the new method to be tested on Horry. It was found to be sure and swift. The first woman falling into Marwood's hands was Fanny Stewart, who murdered her grandson after a tiff with her son-in-law over the broken door of his hen house. Marwood duly did his duty using his newly perfected technique.

Marwood travelled to St Helier in 1875 for the last public hanging in the British Isles, the Channel Isles having been omitted from the 1868 Capital Punishment Amendment Act which ended public executions for murder.

Marwood's 'long drop' proved to be a more humane method of execution. The prisoner died almost instantaneously, mercifully avoiding the dying struggle at the end of a rope, which was kinder to prison staff whose job it was to witness such executions. In Lincoln, revellers would gather at the nearby 'Strugglers Inn' for a gruesome view of Cobb Hall where executions were carried out on its roof.

Back in his Lincolnshire village, Marwood's fame spread and crowds began appearing to catch a glimpse of him. He happily displayed the tools of both his trades, side by side in his shoe shop. After his death there was an abundance of applications for the vacant post of Public Executioner, including many from women.

A popular ditty at the time ran, 'if Pa killed Ma who'd kill Pa? Marwood'.

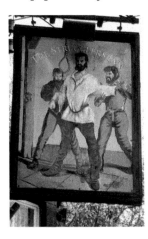

The Strugglers Inn. (By kind permission of the Strugglers Inn. Photo Wendy Turner)

F

Football – Lincoln City: 'The Imps'

The club was originally formed as an amateur association in 1884 although a team had been playing in Lincoln since the 1860s. Their fortunes waxed and waned from 1947 to 1962 under Lincoln City's longest-serving manager, Bill Anderson.

In the 1926–27 season the club signed Notts County goalkeeper Albert Iremonger, one of the tallest players ever in league football at 6′5″ (1.96 m). He was considered by some to be 'the best goalkeeper never to represent his country'. Arsenal goalkeeper Bob Wilson recalls a story, as quoted in *The Telegraph*, that Iremonger once took a penalty for his club. He kicked the ball with such force that it struck the crossbar and went back over his head. Iremonger, 'a lanky stick insect', then raced back to retrieve it and struck a perfect shot into the top corner of his own net. Iremonger Road, off Meadow Lane, home to Notts County FC, is named in his memory.

Sincil Bank has been home to Lincoln City Football Club since 1895.

Forest Stations of the Cross – William Fairbank

William Fairbank's love of timber shines out from each of the Forest Stations displayed in Lincoln Cathedral. Fourteen timber sculptures depict Jesus' journey along the Via Dolorosa, the Way of Sorrows, to the Place of the Skull. The fifteenth Station, entitled *Illumination*, is an invitation to all people to share awareness, enlightenment, insight, inspiration and an understanding that truth is individual.

The artist suffered multiple injuries in a serious road accident in 1987 but, in living with disability, discovered an acute awareness of and an affinity with life seen from a profoundly different view and with different sorts of challenges. The creative therapy of working in wood helped him along the long road back and manifested in the tenderness and dynamic input of his Forest Stations of the Cross.

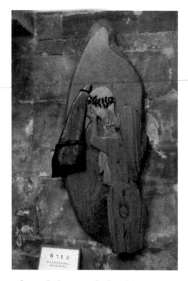

Above left: He is helped by Veronica who wipes his face. (Images by kind permission of William Fairbank and Lincoln Cathedral. Photos Ray Wilkinson)

Above right: Jesus is held down by the crowd as the tools of government drive in the nails.

It took William seven years to create all fifteen stations. A range of 139 different woods from around the world was used, the natural contours of each piece complementing the story and figures. Timbers range from darkest African ebony to lightest ash from Queensland, Australia, blended together in a kaleidoscope of colour to produce the individual figures, crowds and incidents along the way. William's work suggests that anger and crowd pressure incited persecution of Jesus, 'the Truth', who empathises with ordinary people who suffer harsh government and injustice.

The Forest Stations have been meditated upon at Lent and Easter in cathedrals and churches worldwide, bringing the warmth and variety of nature into classic and timeless places of worship. They have been exhibited in cathedrals and churches around the UK including Norwich, Cambridge, Canterbury, Wells and Gloucester and were due to be displayed in Lincoln Cathedral between 2002 and 2004 but have remained there on semi-permanent display. The titles are written in fourteen languages from Arabic and Japanese to Hindi and many European languages. They express his passion for the preservation of our planet's trees and forests, the consequences of global deforestation and protection of natural resources for future generations.

William's Forest Stations take us on a physical and spiritual journey along the nave of Lincoln Cathedral, contemplating the final steps of Jesus the carpenter. The experience invites us to share the thoughts and prayers expressed in his unique Stations of the Cross.

William learned his craft at Ravensbourne College. He lives in Norfolk and is currently working in stained glass.

Forties Weekend

In August celebrations are held for 1940s Lincoln, turning back the clock for a weekend of all things forties. Thousands turn up to relive the era and sing along to popular songs of the time while taking in a host of entertainment, costumed re-enactments, vintage stalls and dance lessons in swing, jitterbug and jive. The city abounds with 1940s uniforms and ladies in A-line tea dresses, furs, peep-toe shoes and forties hats. Gentlemen sport pinstripe suits complete with suspenders, two-tone shoes, fedora hats and even gas masks! The castle is home to a display of vintage cars and military displays while classic vehicles, antique markets and artwork line the streets along with historic displays, children's rides and a happy assortment of food and drink. Weather permitting, a breathtaking RAF Battle of Britain Memorial Flight takes place, while the International Bomber Command Centre (IBCC) holds a host of events to celebrate the weekend (*see* IBBC). The event is organised by Lincoln BIG.

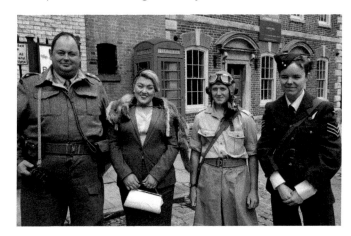

Forties Weekend in Lincoln. (By kind permission of passers-by. Photo Ray Wilkinson)

Forties washing line! (Photo Wendy Turner)

Emily Gilbert

Emily was born in 1872, the fourth child and third daughter of William and Fanny Jane Gilbert, and grew up in a modest 'two-up two-down' house in Waterside South, Lincoln. At school Emily was remembered as a quick pupil with a passion for knowledge.

William Gilbert was manufacturing Penny Farthing bicycles when the biking craze hit and later produced a safer version. Much to her dismay, feisty Emily was barred from cycling but, with a mind of her own, she swapped her long skirt for a pair of her brother's trousers and sped off, becoming Lincoln's first woman cyclist. Another 'first' followed after William expanded his business to include motor cars. Emily became Lincoln's first woman motorist and one of the first women in England to drive.

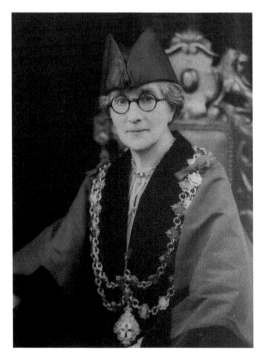

Emily Gilbert. (By kind permission of City of Lincoln Council)

Meanwhile, two of Emily's sisters lived in London. They witnessed gender inequalities and the Suffragette movement in action and relayed their news and views back home. Emily was soon campaigning for women's suffrage. She became well known in Lincoln on business and political fronts and in 1936 at the age of sixty-four, Mayor-Elect Cllr. J. E. Fordham invited her to serve as City Sheriff. Emily was the second woman to hold the office 700 years after Nicola de la Haye battled to save Lincoln Castle (*see* Nicola de la Haye). In her acceptance speech, Emily declared:

> Throughout the years, women have been regarded as anything from chattels to angels but this honour, paid to a woman, is a recognition of the admission of women to full citizenship. With St Paul, I can say that 'I am a citizen of no mean City.' (Alice Rodgers, 2001)

One of Emily's first duties as Sheriff was to announce the new king, George VI, after the abdication crisis of Edward VIII. She died in 1958, at the age of eighty-six.

Great Tom

Weighing in at over 5 tons, you can't miss the sound of Great Tom (the 'bourdon' bell) in the Central Tower. It was originally planned for Great Tom to swing full circle but changes were made after the first attempt out of consideration for the quivering tower. Great Tom is now rung by striking with its clapper.

The oldest bells in the cathedral date from 1593 and 1606 and are rung for services during the week. Bell-ringing practice is held on Thursday evenings by the Company of Ringers, founded in 1612 and thought to be the oldest cathedral tower band in the UK.

Great Tom sounds daily at 3 p.m. in remembrance of the hour when Jesus died.

High Bridge and the Glory Hole

Spectacular High Bridge over the River Witham is unique in that it is the only bridge in Britain that supports buildings. It dates from 1160 with some half-timbered houses added in the 1550s. The houses, now shops, were rebuilt in 1902 by renowned architect William Watkins. The beautiful black-and-white Tudor building on the bridge is now home to Stokes Café, one of Lincoln's well-loved establishments. Its founder, twenty-year-old Robert Stokes, came to Lincoln in 1892 and began his career working in a grocer's shop. In 1902 he took over the business and developed a great love of tea and coffee, winning many awards for his coffee-roasting expertise. In 2002, to celebrate their centenary, Stokes' staff appeared in period dress and served traditional food at 1902 prices.

High Bridge. (Photo Ray Wilkinson)

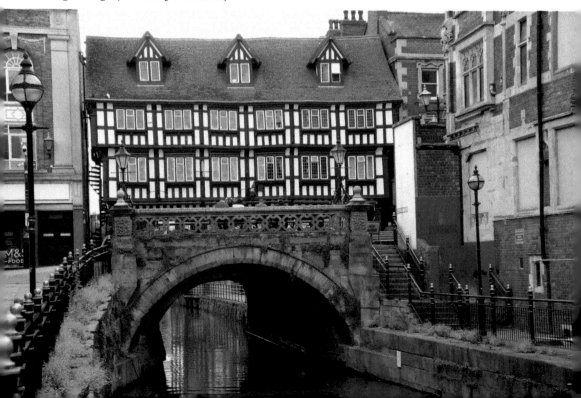

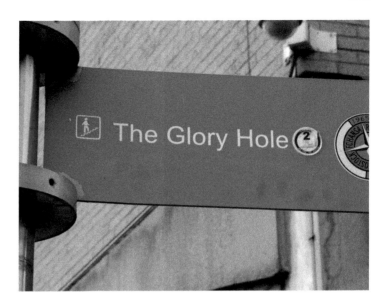

Glory Hole. (Photo Wendy Turner)

The earliest building on the bridge was a chapel built in 1235 and dedicated to Thomas à Becket, Archbishop of Canterbury from 1162 to 1170. Becket was murdered in Canterbury Cathedral after King Henry II uttered the fateful words 'Will no one rid me of this turbulent priest?' The chapel on High Bridge was dismantled in the 1760s to make way for Lincoln's water system.

For a closer view of the underside of the bridge, follow the steps leading down at the side to the Glory Hole, the narrow passageway under the bridge which, with the shallowness of the water, serves to restrict the size of boats on the river. The Glory Hole was once known as the Murder Hole for the number of bodies fetching up there.

Battles have been fought at Lincoln through the centuries, many ending with defeated rebels, outlaws and invaders fleeing for their lives from the castle, down Steep Hill to High Bridge, hoping to escape via the Witham.

Boat trips with an entertaining commentary on Lincoln's local history start from the Brayford Waterfront and offer a closer view of this famous landmark.

HMS *Lincoln*

In the 1970s HMS *Lincoln* became involved in the so-called Cod Wars. A dispute had broken out over fishing rights off the Icelandic coast and Iceland responded by deploying gunboats to harass British trawlers, cutting fishing lines and destroying nets, causing hundreds of thousands of pounds' worth of damage. So reckless was the gunboats' action that the crew of HMS *Lincoln* dubbed one Icelandic captain 'The Mad Axeman'. In response, the British government dispatched Royal Navy frigates to protect the trawlermen. HMS *Lincoln* was one such ship. Caught up in the conflict, the ship was rammed and returned to Chatham Dockyard for repairs. On the evening

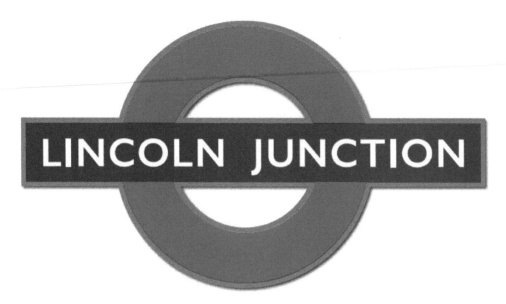

'Lincoln Junction'. (© By kind permission of Roger Paine)

before the next sailing, the crew enjoyed a 'run ashore' where a pint or three was sunk before embarkation. On the way back, a crew member discovered a couple of sections of old railway lines dumped behind a shed. After much humorous debate, they agreed to haul them back, with the idea of using them to protect the ship in some way. A request was left for the shipwright to lop 30 ft or so from each one.

The ship duly sailed and, as there was no time for welding, the two railway lines were lashed down with rope and wire leaving around 50 ft overhanging the stern. The new defence lifted the crew's confidence. Word buzzed and by the next day an aerial photo appeared in *The Telegraph* captioned 'HMS Porcupine Goes to War!' Although the ship suffered further ramming, the stern was fully protected and it returned safely to Chatham. In celebration of the somewhat unofficial but undeniably unique use of the old railway lines, the crew constructed their own sign in the style of the London Underground and 'Lincoln Junction' was born!

St Hugh (1135–1200), the Swan and the Angel Choir

Hugh was born of a noble family in Avalon but as a young child and on the death of his mother, he was taken by his father to live in the Augustinian monastery of Villard Benoît. At twenty, he joined the Order of Carthusians of Grande Chartreuse near Grenoble where he was revered not only for his holy personal qualities but also his fine administrative skills.

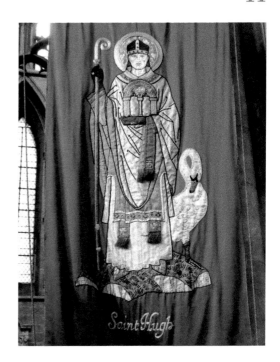

St Hugh and the Swan. (By kind permission of Lincoln Cathedral. Photo Wendy Turner)

Hugh came to the attention of the English king, Henry II, who needed a skilled prior for his new charterhouse of Witham in Somerset, founded by him as a penance for the murder of Thomas à Becket in Canterbury Cathedral (*see* High Bridge). The King sent a special envoy to Hugh in France and, somewhat reluctantly, he took up the post and established England's first Carthusian monastery. Change came in 1186 when Hugh was appointed Bishop of Lincoln but he faced the uphill task of rebuilding and enlarging Lincoln Cathedral after the devastating earthquake of 1185. During his tenure, a breathtaking building in the new Gothic architectural style emerged.

Hugh lived a life of holiness and austerity but he was not afraid to stand up to the monarchs of the day, Henry II, Richard I (Lionheart) and King John, not only criticising aspects of their personal lives but denying funds for their foreign wars and standing up to unjust forestry and taxation laws. He boldly declared that Kings should rule in accordance with God's law. King John was forced to become more accountable and eventually obliged to set his seal to Magna Carta setting out the rights of people and the church (*see* Magna Carta).

Hugh cherished all creation. He served the destitute, the poor and marginalised and lavished care on lepers. He also defended the Jews, who were suffering harsh persecution. In times of retreat, he relished the peace of his manor at Stowe. He loved all animals but felt a special affinity with a wild white swan that was said to take food from his hand and guard him by night. The Swan of Stowe became Hugh's emblem. Many images of Hugh and the Swan can be seen, not least the Willow Swan in Lincoln Cathedral by artist Trevor Leat. The peeled willow swan stands on a heart-shaped green willow base representing the love between Hugh and the Swan.

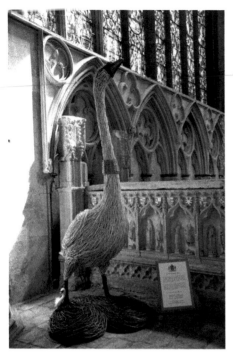

Above left: Willow Swan. (By kind permission of Trevor Leat (Willow Sculptor) and Lincoln Cathedral. Photo Ray Wilkinson)

Above right: St Hugh's Shrine. (By kind permission of Lincoln Cathedral. Photo Wendy Turner)

Hugh died in 1200 before the restoration work was completed and was buried in Lincoln Cathedral. King John himself was a coffin-bearer, followed by the rulers, archbishops, bishops and abbots of the day. In 1220 Hugh was officially declared a Saint by Pope Honorius III.

Over the next thirty or so years, thousands flocked to pray and seek the miracles that were occurring at St Hugh's tomb. To accommodate the ever-growing number of pilgrims, a beautiful shrine and 'Angel Choir' was created at the east end of the cathedral and in 1280 his body was reverently reinterred during a majestic ceremony in the presence of King Edward I and Queen Eleanor (*see* Queen Eleanor of Castile). Admiration and respect were accorded to St Hugh from the highest to the lowest in the land. King Richard (Lionheart) remarked, 'if all the prelates of the Church were like him, there is not a king in Christendom who would dare raise his head in the presence of a bishop'.

St Hugh died in the London residence of the Bishops of Lincoln at Old Temple, Holborn, where Lincoln's inn now stands. His shrine in Lincoln Cathedral has become one of the most acclaimed places of pilgrimage in England. His Feast Day is celebrated on 17 November.

Lincoln Cathedral regularly hosts events and craft workshops where adults and children alike can learn more about St Hugh and the Swan.

I

Imp – The Lincoln Imp in the Angel Choir

The Lincoln Imp sits high above the Angel Choir in Lincoln Cathedral, his right leg crossed saucily over his left knee. Legend has it that he was let loose by the devil and caused chaos in the cathedral, as in H. J. Kesson's (Ursus) 1904 poem:

> The devil was in a good humour one day
> And let out his sprightly young demons to play.
> One dived in the sea and was not at all wet
> One jumped in a furnace: no scorch did he get
> One rode on a rainbow; one delved in the dirt
> One handled fork lightning, not got any hurt
> One strode on the wind as he would on a steed
> And thus to old Lindum was carried with speed
> Where aldermen heard him conceitedly say
> 'There'll be, ere I leave it, the devil to pay'

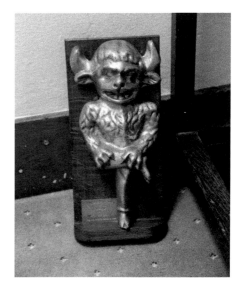

Lincoln Imp. (By kind permission of City of Lincoln Council. Text from *The Legend of the Lincoln Imp* by kind permission of Ruddocks Publishing)

The Imp rampaged through the cathedral showing no respect, but on reaching the Angel Choir, he met his match:

> For the tiniest angel, with amethyst eyes
> And hair like spun gold, 'fore the altar did rise
> Pronouncing these words in a dignified tone
> 'Oh impious Imp, be ye turned into stone!'

If you have 20p, you can light up the Imp set in stone for all time, high up in the Angel Choir. You can follow the Lincoln Imp Sculpture Trail around the city to discover more about Lincoln's famous Imp and the city's art, culture and heritage.

Lincoln Imps can be spotted all over Lincoln, not least as the emblem of Lincoln City Football Club. In 1896 the Prince of Wales, the future Edward VII, wore a Lincoln Imp tie pin when his horse 'Persimmon' won the Epsom Derby.

The legend of the Imp reminds us of mischief afoot, even in a cathedral!

International Bomber Command Centre (IBCC) and The Chadwick Centre

It takes half an hour or so to walk from Lincoln City Centre to the escarpment site of the state-of-the-art IBCC which opened in 2018. With its two Peace Gardens, the centre is an oasis of quiet remembrance of almost 58,000 men and women who lost their lives while serving the Command.

IBCC and the Chadwick Centre. (Photo Ray Wilkinson)

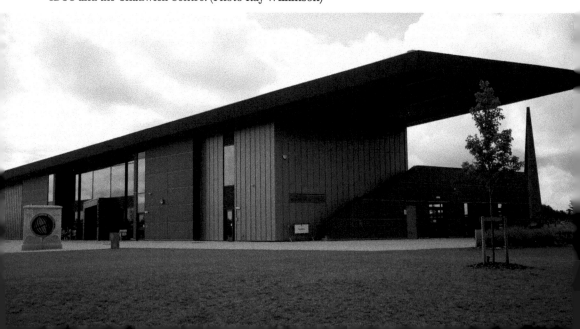

The Peace Sculpture stands outside IBCC's Chadwick Centre, named for Roy Chadwick CBE, FRSA, FRAeS, designer of the famous Avro Lancaster Bomber. Roy Chadwick had a long and distinguished career including working on specialist apparatus needed for aircraft used in the famous Dam Busters raid of 1943 (*see* Lancaster Bomber 'City of Lincoln'). With its message of Recognition, Remembrance and Reconciliation, the Peace Sculpture, created by the cathedral's masonry team, represents the world and the many countries from which service men and women came. It is decorated with Lincoln's insignia, the *fleur-de-lys*, also the symbol of the cathedral's dedication to the Blessed Virgin Mary. The trefoil represents the Holy Trinity.

You can walk through the Chadwick Centre to the Ribbon of Remembrance where engraved paving stones tell of those forever remembered. The Ribbon leads along Memorial Avenue to the Memorial Spire, the UK's tallest war memorial, made of weathering steel. At 31.09 m tall, the spire matches the wingspan of Chadwick's Avro Lancaster Bomber and at 5 m wide at the base, it matches the width of the wing. Visitors to the Memorial Spire are treated to a magnificent 'framed view' of Lincoln Cathedral, which was a vital landmark for Lincolnshire-based aircrew. The Wall

Below left: The Peace Sculpture. (Photo Ray Wilkinson)

Below right: The Spire. (Photo Ray Wilkinson)

Lancaster bomber flies over Lincoln Cathedral. (Photo Ray Wilkinson)

of Names around the spire honours those lost from Bomber Command during the Second World War.

Lincoln provided the perfect location for the IBCC, in the heart of 'Bomber country' with its numerous operational command stations during the Second World War. The IBCC has created a comprehensive free-to-access digital archive on Bomber Command with thousands of interviews, documents and photographs.

IBCC hosts a wide range of events including Animals of Bomber Command, Battle of Britain celebrations, an annual carol concert and a 'Forties Weekend' where you can sport a forties hairdo, take forties dancing lessons for the Blackout Blitz Ball and enjoy a vintage tea with Spitfires flying overhead.

J

'Joust of Lincoln'

It is well documented that in medieval times Stephen and Matilda fought for the crown, but perhaps it is not so well known that Lincoln Castle had a starring role in the dispute.

When Henry I, son of William the Conqueror, died in 1135, the legitimate heir was his daughter, Matilda. The Council, however, decided against a woman and crowned Stephen of Blois, grandson of the Conqueror, sparking off years of unrest and civil war.

Stephen, something of a weak monarch, was soon challenged by Matilda and her supporters. In 1141 his forces laid siege to Lincoln Castle which had been seized by Matilda and held on her behalf by Ranulf, Earl of Chester. Savage warfare broke out. Ranulf escaped the castle and returned with a relieving force loyal to Matilda under the command of her half-brother Robert, 1st Earl of Gloucester. The royalists, on horseback, charged with their lances in a grim theatre of jousting. Hand-to-hand fighting followed but Stephen fell and was imprisoned at Bristol where he languished until being restored to the throne in exchange for the freedom of Robert who had been captured. In 1148 Matilda retreated to France never to return, but her son Henry became Henry II of England in 1154.

A Grand Joust is held at Lincoln Castle in celebration of the 'Joust of Lincoln', complete with colourful characters in medieval dress.

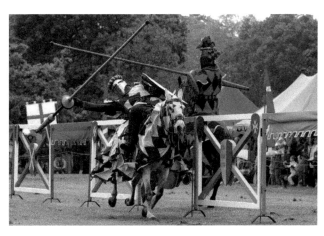

Knights of Royal England at Warwick Castle. (Photo National Jousting Association)

Katherine Swynford (1350–1403), Duchess of Lancaster

It's said that Katherine fell in love at first sight with John of Gaunt, Duke of Lancaster, third son of King Edward III but he was married to the beautiful and fabulously wealthy Blanche of Lancaster. Katherine married Hugh Swynford, a knight in the Duke's service. They lived at the Manor of Kettlethorpe in Lincolnshire.

Katherine's father, Paon de Roet, a Flemish herald, had brought his family to England from Hainaut, Belgium, in 1351. Katherine later took up the post of governess in the Duke's household caring for his and Blanche's two daughters, Philippa and Elizabeth.

Katherine had her own little daughter, also Blanche, and the three girls grew up together but tragedy struck in 1368 when the Duke's wife, Blanche, lost her life to the Black Death. Katherine's husband, Hugh, died of dysentery while in France.

Katherine and the Duke began a relationship that was to last a lifetime. They produced three sons and a daughter, the 'Beaufort' children, but any hopes Katherine harboured of marriage were dashed when the Duke pursued his dream of becoming King of Castile by marrying Constanza of Castile in 1371. Katherine returned to Kettlethorpe but things

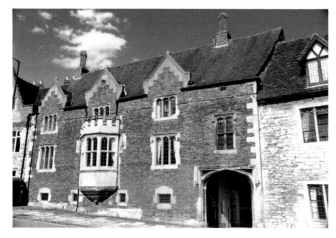

Katherine Swynford's house on Pottergate.
(Photo Ray Wilkinson)

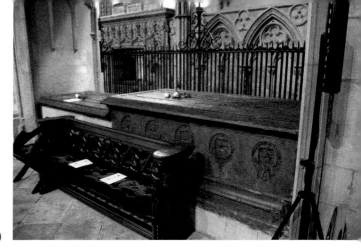

Katherine Swynford's tomb.
(By kind permission of Lincoln
Cathedral. Photo Ray Wilkinson)

changed in 1394 when Constanza died. Her dream finally came true in 1396 when she and the Duke married in Lincoln Cathedral and their four children were legitimised. Sadly, the couple had but three years together before the Duke died.

Katherine died in 1403. She was buried in Lincoln Cathedral next to the tomb of her daughter, Joan Beaufort. Katherine's sister Philippa married the English poet Geoffrey Chaucer, author of *The Canterbury Tales* (*see* Chaucer).

In 1399, the year of the Duke's death, Richard II seized the entire Lancastrian estate. He was deposed by Henry IV, son of the beautiful Blanche of Lancaster. Soon after, Richard II was murdered in Pontefract Castle.

Katherine once lived in a house on the Chancery, Pottergate, near Lincoln Cathedral where her son, Henry Beaufort, was Bishop. Some parts of the Chancery date back to the thirteenth and fourteenth centuries. In 1480 the front was reconstructed, resulting in it being Lincoln's earliest existing brick building.

King Slayer! Edward Whalley

Robert Becke, twice mayor of Lincoln in the 1600s, was a wealthy wool merchant in business with his son, John. Both sat on the Corporation as aldermen.

Robert was a Royalist during the Civil War. In 1647 he was fined £60, a considerable sum, and was dismissed from the Corporation 'for having borne commissions in the army of their sovereign'. John remained and also went on to serve as mayor but after the Restoration he was dismissed for 'having favoured the measures of Parliament'.

The mission of Cromwell and the Puritans during the Civil War was to rid the church of the so-called Catholic influences. They became fierce enemies of the King, Charles I, whom they suspected of being a secret Catholic with his French-born Catholic wife, Henrietta Maria. Religious fervour drove them to extreme lengths, culminating in the beheading of the monarch in 1649.

Puritan Edward Whalley, Cromwell's second cousin, came to Lincoln in 1655 as Administrative Major-General during a period of direct military rule, part of Cromwell's Protectorate, and was honoured with the Freedom of the City. Whalley's signature appears on the death warrant of King Charles I and he is thus a 'king-slayer'.

Lancaster Bomber 'City of Lincoln' and the Dam Busters

RAF Coningsby has been one of the RAF's main operating bases in the UK since 1941. Among its iconic aircraft collection is the Lancaster Bomber 'City of Lincoln', one of only two remaining flying Lancaster Bombers, the other being in the Canadian Warplane Heritage Museum. The Lancaster was instrumental in the Second World War in what was essentially a fight for national survival.

Lancasters were world-class and the most successful heavy bomber of the Second World War. Their huge exterior is deceptive; conditions inside the aircraft are extremely cramped due to its vast bomb bay.

The Avro Lancaster entered combat in 1942 and during the Second World War took part in thousands of missions against German targets. They are revered today for their role in the daring Dam Busters raid carried out by 617 Squadron. Their mission was to

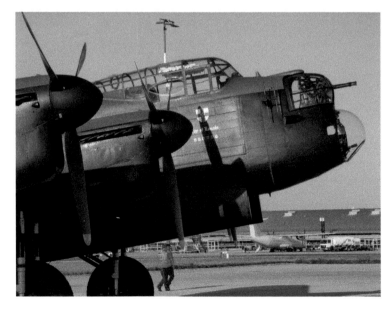

Lancaster bomber 'City of Lincoln'. (Photo Wendy Turner)

destroy three dams in the German Ruhr valley which would disrupt power and water supplies and thereby damage German industry, courtesy of Dr Barnes Wallis' famous 'bouncing bomb'. To be effective, the bomb needed to skip across the water, roll down the face of the dam wall and explode underwater at the base. Dr Wallis perfected the technique using marbles in a tub of water in his garden. Aircrews practised flying their huge, specially adapted Lancasters low over Derwent Dam, Derbyshire.

The 133 airmen in nineteen Lancaster Bombers took to the skies in *Operation Chastise* on the night of 16–17 May 1943. Their average age was twenty-two. They flew in three waves led by twenty-four-year-old Wing Commander Guy Gibson flying in the first wave. The mission was carried out at night although the dams were fiercely defended and surrounded by steep hills, trees and a church spire. The bombs needed to be dropped from a height of 18 m at a ground speed of 232 mph. To achieve pinpoint accuracy, a pair of lights was attached to the underside of the aircraft – the beams converged on the surface of the water at the correct height. The huge planes flew so low it was feared they might crash into the trees.

In the event, two of the dams were breached. The cost was eight bombers lost, fifty-three aircrew killed and three becoming prisoners of war but for the Allies the raid was a huge boost to morale. The 617 Squadron became a specialist precision-bombing unit. A commemorative plaque at Derwent Dam honours their endeavours.

In November 1944 in a joint operation with 617 and 9 Squadron, the German battleship *Tirpitz* was attacked and destroyed when 12,000-lb Tallboy bombs were deployed. The heaviest single bomb carried by a Lancaster was the colossal 22,000-lb Grand Slam.

Derwent Dam. (Photo Wendy Turner)

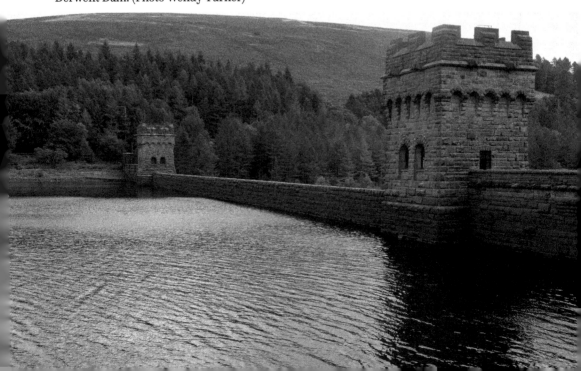

Memorial at Derwent Dam. (Photo Ray Wilkinson)

Wing Commander Guy Gibson VC, DSO, DFC was the first and most highly decorated Commanding Officer of 617 (Dam Busters) Squadron. In 1944 at the age of twenty-six he was killed in action flying a Mosquito aircraft in Europe. Sir Barnes Neville Wallis CBE, FRS, RDI, FRAeS took on aeronautical research and development at the British Aircraft Corporation. He became a Fellow of the Royal Society and was knighted in 1968. He died in October 1979.

On 24 January 2020 Guy Gibson's RAF 'wings' badge was flown over the City of Lincoln in an RAF Typhoon jet to mark the 'Bastion in the Air: A century of Valour' exhibition at The Collection Museum. It finally completed the 'home-coming' of one of Lincoln's best-loved sons. The Typhoon pilot said, 'It's a huge honour and privilege to be asked to carry his wings with me as I fly over Lincoln today.'

RAF Coningsby is one of two Quick Reaction Alert stations protecting UK airspace and a training station for Typhoon pilots.

Air Chief Marshal Sir Arthur 'Bomber' Harris summed it up in 1945:

> I would say this to those who placed that shining sword in our hands: without your genius and efforts we could not have prevailed, for I believe that the Lancaster was the greatest single factor in winning the war.

The famous 1955 film *The Dam Busters* tells the story of the Lancasters' audacious raid in 1943 with Richard Todd as Guy Gibson and Michael Redgrave as Barnes Wallis.

Land Lighthouse

In the eighteenth century, land a few miles south of Lincoln was a vast and dangerous heathland. Travellers to and from Lincoln became prime targets for robbers and highwaymen, especially during the hours of darkness.

Enter Sir Francis Dashwood MP (1708–81), 15th Baron le Despencer of West Wycombe, Buckinghamshire. Although famed for his founding of the 'Hellfire Club' and his rakish lifestyle, he was also a philanthropist and an activist on social issues. He pondered the problem of the attacks and murders on the heath as outlined by his wife Sarah of Nocton Hall, Lincolnshire, and came up with the novel idea of a land lighthouse. When finally built in the mid-1750s, it stood around 30 m tall with spiral stairs up to its octagonal lantern. The land Lighthouse became a popular landmark both during the day and at night when illuminated. Sir Francis cultivated the surrounding area with plantations and pavilions and even added a bowling green. The area buzzed with sightseers from near and far. Standing in the parish of Dunston, a few miles south of Lincoln, it became known as the 'Dunston Pillar'.

After Francis' death, the structure stood firm for many years until the lantern toppled in a storm. The new owner replaced it in 1810 with a huge bust of George III in celebration of his fifty years on the throne.

In 1939 and on the creation of nearby RAF Coleby Grange, the building was a clear hazard. It was reduced in height to tree level and the King's statue taken down, leaving only a stump as witness to its former glory. King George's bust now rests in the grounds of Lincoln Castle. The surviving part of the tower and the bust of the king are both listed Grade II.

Lawrence of Arabia (1888–1935) T. E. Lawrence CB. DSO

Brown's Pie Shop & Restaurant at 33 Steep Hill is a notable address in Lincoln city. It once had an iconic tenant in the shape of T. E. Lawrence, better known as Lawrence of Arabia, although then known as T. E. Shaw.

Thomas Edward Lawrence was born in 1888 in Tremadoc, North Wales. His father, Thomas Chapman, was an Anglo-Irish baronet and his mother, Sarah Junner, had been governess to Chapman's four daughters by Lady Chapman. Thomas and Sarah left together when their liaison was discovered and settled in Oxford after various moves around the UK, Jersey and Normandy. They never married but took the assumed name of 'Lawrence' and eventually produced five sons.

T. E. Lawrence, their second son, attended Jesus College Oxford and in 1909 as part of his studies spent three months in Syria visiting castles and archaeological sites for which he had developed a passion. After graduating with a First in History, he was taken to an ancient Hittite site, now on the Turkey/Syria border. While there, he got to know the local people and learned Arabic and, as the First World War approached, helped provide archaeological cover for military mapping in the Sinai.

Lawrence returned to England where his special talents were soon recognised and put to good use in the Arab Bureau in Cairo when the Ottoman Empire, led by

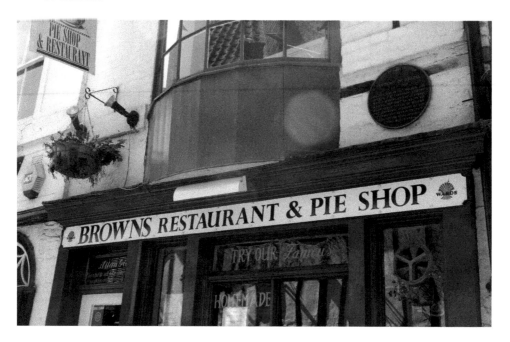

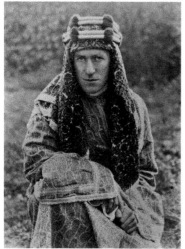

Above: Browns Restaurant & Pie shop, Steep Hill.
(Photo Wendy Turner)

Left: T. E. Lawrence. (Courtesy of the National Library
of Norway)

Turkey, entered the war on the German side. At the onset of the Arab Revolt in 1916, he travelled to Jedda and joined forces with Prince Feisal and the Bedouin tribes in guerrilla tactics against the Ottomans, destroying their supply lines with lightning raids and attacks on the railway. It culminated in the audacious attack and capture of the Red Sea port of Aqaba and, working with General Edmund Allenby's forces, they eventually reached Damascus.

Lawrence returned home and campaigned on behalf of his friend and comrade Prince Feisal. In 1921 it was agreed that the Prince would take the throne of Iraq. Lawrence, at the invitation of Winston Churchill, worked as an adviser at the Colonial Office.

For Lawrence, however, the lifestyle had taken its toll. Suffering from post-traumatic stress disorder, he sought to fade from public gaze. He joined the RAF as an Aircraftsman and changed his name to 'Shaw', but the media were never far behind. He moved on to the Tank Corps in Bovington, Dorset, where he bought Clouds Hill Cottage.

In 1925 Lawrence was posted to the Cadet College at RAF Cranwell, Lincolnshire. He craved peace and quiet to pen his account of his role in the Arab Revolt and rented a room in Brown's Pie Shop on Steep Hill in the heart of Lincoln city, returning to Cranwell on his Brough SS100 motorbike. Lawrence's adventurous spirit was never far away: he wrote of racing a Bristol fighter aircraft along the lanes of Lincolnshire.

Lawrence's career in the RAF came to an end in 1935 when he returned to Clouds Hill. Later that year, his life came to an abrupt end when he swerved across the road on his motorbike to avoid some delivery boys and sustained severe head injuries. He lingered in a coma for six days but died at the age of forty-six and was buried in Moreton churchyard, close to his Clouds Hill home. On his death, Winston Churchill remarked to a friend that 'in Colonel Lawrence we have lost one of the greatest beings of our time'.

T. E. Lawrence is remembered as an archaeologist, a scholar and philosopher and military strategist. His autobiographical book *The Seven Pillars of Wisdom* was published in December 1926. Its title is taken from the *Book of Proverbs 9:1*:

Wisdom has built her house, she has hewn out her seven pillars.

In 1962 the Hollywood blockbuster *Lawrence of Arabia* burst onto cinema screens with Peter O'Toole in the leading role, bringing his story to a new audience. A plaque outside Brown's Pie Shop commemorates the time T. E. Lawrence, as Aircraftsman Shaw, spent there working on his epic book.

Lodging in a pie shop not too far from work sounds an ideal arrangement for any young man!

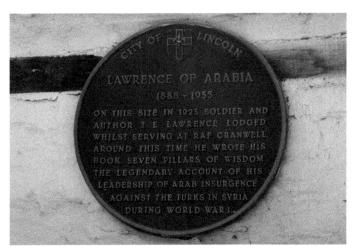

Lawrence plaque, Steep Hill. (Photo Wendy Turner)

Level Crossing

In 1954 Geoffrey de Freitas, MP for Lincoln, stood up in the House and demanded, 'Why, because of a mistake made a hundred years ago, should their lives be made intolerable by this obstruction across the main artery of the city?'

The debate referred to disruption due to the railway that carves its way through the heart of Lincoln city. Mr de Freitas campaigned for a footbridge to alleviate waiting time at the barrier. He made reference to Colonel Sibthorpe, MP for Lincoln in the 1800s (*see* Stonebow and Guildhall), and recalled that the Colonel was 'a great complainer, specifically about railways, to the extent that in 1844 he was caricatured in *Punch* magazine as attacking a railway engine with a lance, mounted like Don Quixote!'

Today, when the klaxon sounds and the barriers descend, you may decide to wait for trains to pass or wait even longer for a freight train with endless wagons. Alternatively, you may cross by the footbridges that Mr de Freitas passionately fought for.

Lincoln's 'stop as you shop' is something of a feature in the city but thankfully today need not delay your outing.

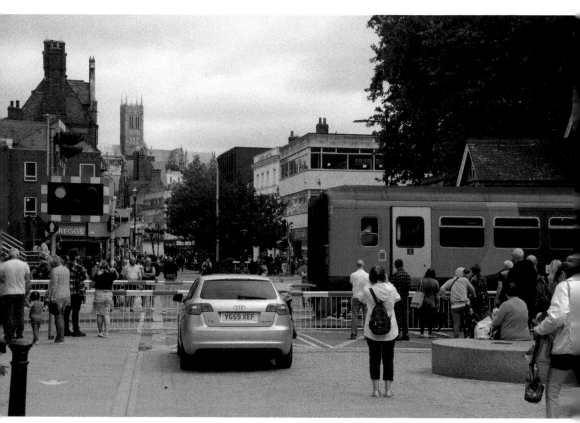

Level crossing, town centre. (Photo Ray Wilkinson)

Lincoln Green

So prosperous had Lincoln become in the Middle Ages with its wool and cloth industries that by the end of the thirteenth century it was England's third largest city. 'Lincoln green/greene', as popularised in stories of Robin Hood, brought enormous wealth to traders and weavers. To achieve the attractive olive-green colour, wool was first dyed with woad turning it a deep sea blue and then re-dyed with yellow Dyer's Broom. The two colours produced Lincoln Green, renowned for the high quality of the dye and its colour consistency and fastness. Dyer's Broom remains in use today.

The more expensive Lincoln scarlet was produced by treating material with dye from the Mediterranean insect Kermes vermilio (vermillion). The process used crushed and dried adult female insects and was a skill well known to the Romans. As an import, Kermes vermilio was a far more costly dye than home-produced Lincoln Green. Scarlet cloth was accordingly seen as superior to green, and green was seen as superior to undyed shepherds' grey cloth.

The story goes that when Robin Hood had occasion to be in court, he was clothed in scarlet denoting his elevated status. One of Robin's Merry Men was Will Scarlet who dressed in scarlet silk.

Edmund Spenser (1552–99) in his poem *The Faerie Queene* described Robin Hood:

> All in a woodman's jacket he was clad
> Of Lincolne Greene belay'd with silver lace

The poem is in veiled praise of Elizabeth I (Gloriana), herself the 'Faerie Queene'.

It seems most appropriate that Richard Greene played Robin Hood in the long-running TV series *The Adventures of Robin Hood* in the 1950s! (*see* Robin Hood).

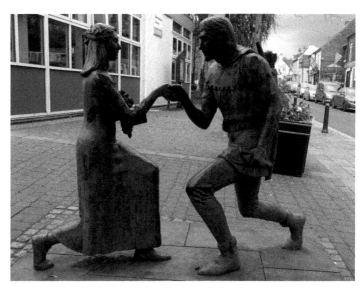

Robin and Marian.
(Neale Andrew:
Robin and Marian at
Edwinstowe. Photo Ray
Wilkinson)

John Gillespie Magee Jr (1922–41)

John Gillespie Magee was born in Shanghai of missionary parents. At the age of seventeen he earned a scholarship to Yale but during the Second World War he became a pilot in the Royal Canadian Air Force and arrived in England in 1941 at RAF Digby, Lincoln. The sheer joy that he found in flying comes across in his famous poem *High Flight*:

Oh! I have slipped the surly bonds of Earth
And danced the skies on laughter-silvered wings;
Sunward I've climbed, and joined the tumbling mirth
Of sun-split clouds, – and done a hundred things
You have not dreamed of – wheeled and soared and swung
High in the sunlit silence. Hov'ring there,
I've chased the shouting wind along, and flung
My eager craft through footless halls of air ...

Up, up the long, delirious burning blue
I've topped the wind-swept heights with easy grace
Where never lark, or ever eagle flew –
And, while with silent, lifting mind I've trod
The high untrespassed sanctity of space,
Put out my hand, and touched the face of God

In December 1941 Magee's Spitfire was involved in a mid-air collision over Lincolnshire which cost the lives of both pilots. He was just nineteen. He was buried in Scopwick churchyard a few miles south of Lincoln and you can read his poem in Scopwick Parish Church.

President Reagan quoted from *High Flight* in a live broadcast after the *Challenger* space shuttle exploded in 1986:

We will never forget them, nor the last time we saw them, this morning, as they prepared for their journey and waved goodbye and 'slipped the surly bonds of earth' to 'touch the face of God'.

Magna Carta

History records King John, youngest son of Henry II, as thoroughly dislikeable, greedy and untrustworthy. He came to the throne in 1199 despite the greater popularity of his twelve-year-old nephew, Arthur of Brittany. Arthur, thought to be named by John's elder brother, Richard the Lionheart, as his successor, disappeared in his youth and was almost certainly murdered on John's orders.

Within a few years of his reign John had lost large swathes of French lands acquired by King Henry through marriage and inheritance. John's taxation policies became increasingly aggressive as he demanded funds to try to regain them, putting him on a collision course with his powerful barons and the church, but on 15 June 1215 John was forced to set his seal to the Magna Carta at Runnymede near Windsor, an ancient site used for gatherings over the centuries. Magna Carta limited the power of the monarch and granted people more rights and freedoms. An inscription on the memorial at Runnymede reads:

> To commemorate Magna Carta
> Symbol of Freedom under Law

A direct reference to Clause 39 of Magna Carta is inscribed in Latin on the third of The Jurors at Runnymede, granting people the right to be tried by their peers if accused of a crime.

The Jurors, Runnymede (maintained by the National Trust). (Hew Locke: The Jurors, Runnymede. Photo Yvonne Moxley)

Hugh of Wells, Bishop of Lincoln, was present at Runnymede and brought back his Magna Carta, inscribed 'Lincolnia' on the reverse, for the City of Lincoln. It was kept securely in the cathedral for the next 600 years and is one of only four of the 1215 issue in existence.

Within a few weeks, John had reneged on his promises and civil war broke out but he died suddenly in 1216 at Newark and his son, nine-year-old Henry, succeeded as Henry III under his regent, William Marshal, Earl of Pembroke. Meanwhile, the rebel barons had plotted for Prince Louis, son of the French king, to take the English crown in return for the support of the French. The young Louis and his army crossed the Channel, landing in Kent in May 1216. They had some initial success in gaining ground but clashed with the English at the Second Battle of Lincoln, fought on Lincoln's streets in May 1217. William Marshal finally led the English army to victory and the French fled (*see* Nicola de la Haye). Neither the young Henry nor Louis was present: Henry was kept safe in Nottingham while the French battled to take Dover. Magna Carta was reissued in 1217 by Henry III together with his *Charter of the Forest* which granted people greater freedoms from the severe forest laws.

Lincoln Castle is the only place in the world where you can view both original documents, on permanent loan from Lincoln Cathedral. They are housed in the castle's specially designed David P. J. Ross Magna Carta Vault. Entrepreneur and philanthropist David P. J. Ross is co-founder of The Carphone Warehouse Group and an alumnus of Nottingham University. His philanthropic work is carried out through the David Ross Foundation.

Sir Neville Marriner CH CBE

Born in Lincoln in 1924, Neville learned violin and piano from his father. He attended Lincoln School and later studied with the Royal College of Music in London and the Paris Conservatoire. His career was interrupted by the Second World War where he served in Army reconnaissance. After a spell in hospital he was invalided out and returned to the RCM.

Neville performed with the Philharmonia and the London Symphony Orchestra and went on to conduct many world-famous orchestras. In 1958 he founded the internationally acclaimed Academy of St Martin-in-the-Fields, a London chamber orchestra which became the most extensively recorded chamber orchestra in the world. He directed and conducted major symphony orchestras worldwide. His work broadened to include opera, particularly the works of Mozart and Rossini. Into his nineties he was still travelling the world with the Academy and conducting major symphony orchestras. The Academy won a Queen's Award for Export Achievement.

Sir Neville Marriner was appointed CBE, knighted and made Companion of Honour. He died in October 2016 at the age of ninety-two. A blue plaque marks his home in Grafton Street, Lincoln.

Sir Neville Marriner
CH CBE. (© By kind
permission of Meirion
Harries)

Mount Everest and Mary Everest Boole

Mathematician Mary Everest was born in 1832 in Gloucestershire. She met and married George Boole, Lincoln's eminent mathematician, in Cork, Ireland. In an age where women were not accepted into academia, Mary nevertheless made her mark as a woman of considerable intellect whose publications and essays include works on logic, geometry, psychology and algebra among many other topics. She was said to be an exceptional teacher.

Mary's uncle, Colonel Sir George Everest, was part of the British-sponsored *Great Trigonometrical Survey* which mapped the Indian subcontinent during the 1800s. The survey identified the highest mountain in the world in the Himalayas, then known as Peak XV. In 1865 the mountain was named Mount Everest by the Royal Geographical Society in honour of George Everest's work and his life spent mostly in India.

As a child, Mary loved to hear of George's adventures in India and he relished her interest in them. So close did they become that he planned to adopt her but could not secure her parents' agreement. Mary died in 1916 at the age of eighty-four.

Nicola de la Haye (Haie) (*c*. 1150–*c*. 1230)

Centuries before the time of Queen Elizabeth I, Nicola de la Haye could have claimed 'to have the body of a weak and feeble woman, but the heart and stomach of a king'. Maybe not a king but a strong and formidable Constable of Lincoln Castle during the turbulent years of the reigns of Richard the Lionheart, his brother, John and John's son, Henry III.

Nicola de la Haye Building, University of Lincoln. (By kind permission of University of Lincoln. Photo Wendy Turner)

Lincoln Castle has been a much-desired stronghold, battled over through the centuries and became once again embroiled in 1191 when Prince John made a bid for the crown in King Richard's absence on crusade. Nicola's husband, Gerard de Camville, Constable of the castle, supported John but Richard's Chancellor, William de Longchamp, arrived on the scene and his forces laid siege to the castle. Nicola, in her husband's absence, was said to have 'defended the castle like a man'. A peace agreement was eventually reached.

John was in Lincoln again in 1200 but during the visit Hugh, beloved Bishop of Lincoln, died (*see* St Hugh and the Swan). Such was the outpouring of love and respect for Hugh that John stayed on for the funeral and even helped bear his coffin.

The position of Constable of the Castle had fallen to Nicola on the death of her father, Richard de la Haye, in 1169 and again on Gerard's death. They were dangerous times: John had become King in 1199 on the death of the Lionheart and was forced to set his seal to Magna Carta in June 1215, but civil war broke out soon after when he failed to honour its terms. John marched through eastern England but contracted dysentery and died at Newark Castle in 1216 at the age of forty-nine, having made Nicola, then in her mid-sixties, Sheriff of Lincolnshire.

In May 1217 rebel barons, who had allied themselves with the French, besieged Lincoln Castle and boulders hurled from catapults threatened to shatter Nicola's castle walls. Relief came with William Marshal, Earl of Pembroke, Regent for the nine-year-old King Henry III, and a select task force of archers who had gained access to the castle through the West Gate. As Nicola and her forces rained down arrows on the French in the lower city, the Royalist army attacked through the North Gate (Newport Arch) and savage fighting took place outside the cathedral. Sensing defeat, the rebel barons and their allies fled. Many were taken prisoner or drowned in the Witham along with local people attempting to flee the carnage and looting that followed (*see* Magna Carta). The conflict was dubbed 'The Second Battle of Lincoln'. Nicola finally retired and surrendered control of the castle in 1226. She died four years later.

Nicola became known as 'the woman who saved England'. King Henry III referred to her as 'Our beloved and faithful Nicola de la Haye' and royalist writers described her as 'a worthy lady deserving God's protection in body and soul'.

At a time when women had little standing, Nicola de la Haye emerged as a purposeful and strong leader, steadfast in the face of siege warfare. 800 years after the Second Battle of Lincoln, the University of Lincoln renamed the west wing of the Art, Architecture and Design Building in her honour.

George Orwell's Essay on Donald McGill

In 1941 writer, journalist and critic George Orwell published his essay *The Art of Donald McGill*. McGill's name may not be immediately familiar but his popular postcards may well be. They portrayed cheeky young things, obese mothers-in-law or the wife in curlers brandishing a rolling pin, among many other scenarios. Thousands were sent by people away on holiday to friends and family and were sure to raise a smile.

In the somewhat stern and moral 1950s, McGill's cheeky art was frowned upon by the authorities and a crackdown ensued. Bundles of his postcards were seized and destroyed and the police, often the butt of McGill's jokes, raided shops, not least around the Lincolnshire coast. It all culminated in a trial in 1954, held in Lincoln under

George Orwell. (Photo Branch of the National Union of Journalists 1933 (BNUJ))

Donald McGill. (© By kind permission of
Mr P. Tumber)

the 1857 Obscene Publications Act. McGill argued his case that no *double entendres*
were intended in his artwork, but he was nevertheless fined with costs.

In his essay, George Orwell pondered the genre of the English 'saucy' postcard and
observed:

> McGill is a clever draughtsman with a real caricaturist's touch in the drawing of
> faces, but the special value of his post cards is that they are so completely typical.
> They represent, as it were, the norm of the comic post card.

Throughout his career spanning over fifty years, Donald McGill produced thousands
of different artworks for his comic and social postcards with an estimated 200 million
being sold. *Punch* magazine described him as 'the most popular, hence most eminent
English painter of the century'.

Peregrine Falcons

You can watch nature unfold high up on the central bell tower of Lincoln Cathedral courtesy of live-streaming brought to you from a partnership of volunteers from Lincoln Cathedral, University of Lincoln, Quickline Internet Solutions and the RSPB. Information booths in the cathedral grounds at weekends enable visitors to observe the beautiful birds from telescopes at the viewpoint.

Peregrines have been nesting and performing spectacular aerobatics around the heights of the cathedral for around fifteen years. You can catch all the action on YouTube with close-ups of both parents swapping nest-sitting duties, diving and chasing prey and returning to the nest to feed their growing chicks.

Peregrine falcon on Lincoln Cathedral. (© By kind permission of Peter Skelson, Lincoln RSPB)

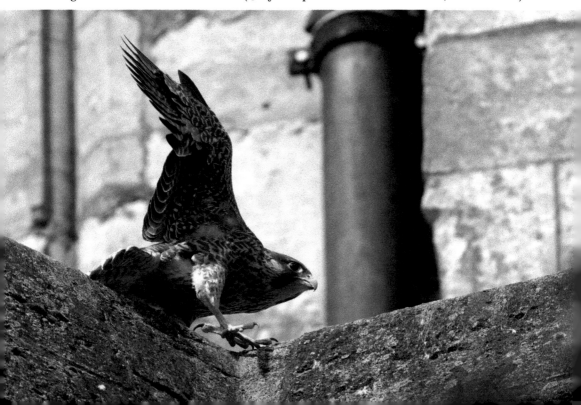

Peregrine numbers fell alarmingly in the 1960s due to persecution and egg theft, which resulted in them becoming a Schedule 1 listed species of The Wildlife and Countryside Act 1981. They have since made a remarkable comeback. Once seen mostly on rocky coastlines and uplands of the UK or hunting above east coast marshland, they now venture into towns and cities as more legislation and protection for them comes into force.

Peregrines are large and commanding falcons and can reach speeds of over 200 mph when dive-bombing for prey. They mostly hunt pigeons, ducks and small wading birds, sometimes killing them in mid-air. There are around 1,500 breeding pairs in the UK.

It's a joy and a rare opportunity for visitors and residents alike to see nature at its best in the midst of the beautiful city, as these stunning and agile birds tenderly parent their young high up on Lincoln Cathedral. The event has become something of a highlight of summer in Lincoln.

Posy Ring

In 1578 the Posy Ring was bequeathed to the common chamber, which was the collective body of the corporation, by Edward Sapcote, with the words, 'in token of my goodwill borne to the city of Lincoln ... a ring to be successively worn by the Mayor of Lincoln that for the time shall be'.

'Poesy' refers to a poetic phrase as in the Latin verse engraved on the ring: *Omnis caro fenum – all flesh is grass,* indicating the transience of life. The ring is presented to every new mayor of Lincoln to proclaim that he or she is 'married to the city' for a year and that they will serve it and its citizens for their year in office. The ring is placed on the mayor's thumb and traditionally worn twice during the year of office.

The year 1835 saw the start of a new tradition in Lincoln. The Posy Ring was taken to Lincoln Grammar School, symbolic of the school submitting to the authority of the old corporation, and the boys were given a day's holiday. The practice continued from year to year until 1852 when all schools in the city received the ring, with a visit from the mayor. Today the mayor visits more than twenty-five primary schools and talks to over 9000 children.

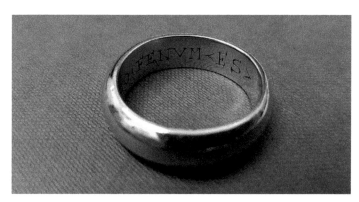

Posy Ring. (By kind permission of City of Lincoln Council)

Prison

The eighteenth-century social reformer and author Samuel Bamford was but one of many notable prisoners incarcerated in Lincoln Castle's gaol accused of 'a seditious conspiracy to overthrow the Government'. Sympathetic to the plight of working-class people, he spoke out at a peaceful rally held in St Peter's Field, Manchester, in 1819. A crowd of around 60,000 had gathered to hear speakers demanding parliamentary and voting reform but the event was interrupted by a savage sabre-brandishing cavalry charge, authorised by the authorities, in which an estimated eighteen people died and hundreds were badly injured. The event became known as the *Peterloo Massacre*, which inspired the poet Percy Bysshe Shelley to pen his famous *Mask of Anarchy*:

> And a mighty troop around,
> With their trampling shook the ground,
> Waving each a bloody sword,
> For the service of their Lord.

After his year in gaol, Bamford wrote his autobiography, *Passages in the Life of a Radical*, describing his time in Lincoln Prison. *Peterloo* became a key event that sparked change in attitudes to democracy and voting rights. It inspired the 2018 film *Peterloo* directed by Mike Leigh with the part of Samuel Bamford played by Neil Bell.

The Georgian gaol was completed in 1788 and held both felons and debtors but the felons' wing was replaced with a new Victorian prison wing, built in 1845–48. The Separate System was in force and prisoners were kept in total isolation, thought to improve their moral welfare, including being forced to occupy high-sided individual stalls in the castle's chapel which ensured they saw no one. Judgement was harsh and many were hanged for crimes now seen as petty. Notable prisoners include Samuel Wesley (for a debt of £30), father of John and Charles Wesley, founders of the Methodist Church, and early Quaker Elizabeth Hooton. Elizabeth wrote blazing letters to the authorities setting out the terrible and unsanitary conditions in the prison. She called for separate medical facilities for men and women and suitable work for prisoners who were obliged to unpick old ropes, pump water or make straw mats. After her release, she crossed the Atlantic in the company of George Fox, founder of the Quaker movement. George had also served time in Lincoln Gaol for his outspoken religious views. Elizabeth died in Jamaica in 1672.

The castle's prison ceased use in 1878 but today's Gothic Revival courthouse is still used for criminal trials, heard by Lincoln Crown Court. Lincoln Castle is the only castle in the country from where justice is still dispensed. One of the prison's exercise yards was used for prison scenes in TV's *Downton Abbey*.

Queen Eleanor of Castile

In 1254 fifteen-year-old Edward I married thirteen-year-old Eleanor of Castile. They were deeply devoted and Eleanor accompanied him on many journeys, not least on crusade. In their thirty-six-year marriage they produced around sixteen children. Many died in infancy but some survived, including the future Edward II.

Edward I, known as 'Longshanks' for his tall, lean frame, was a great reformer and, under him, civic business was conducted through Parliament. He was also an outstanding soldier, engaging the Scots so fiercely he earned the title 'Hammer of the Scots'.

In 1290 Edward sent for Eleanor to join him on his way to war in Scotland. Sadly, she fell ill on the way. Edward hastened to her side but she was given the last rites and died, at the age of forty-nine, at Harby in Nottinghamshire.

Edward was devastated by Eleanor's death. She was embalmed and her viscera (entrails) interred in Lincoln. Her body was conveyed to London where, in accordance with her wishes, her heart was buried in Black Friars Monastery. At every resting place Edward raised a stone 'Eleanor Cross' memorial bearing her likeness, a reminder to passers-by to pray for her. You can see a fragment of Lincoln's Eleanor Cross, a Grade II listed monument, in the castle grounds, which shows just a remnant of her

The Passing of Queen Eleanor. (© By kind permission of the Cathedral and Abbey Church of St Alban)

THE PASSING OF QUEEN ELEANOR

This painting by Frank O. Salisbury shows the honour paid at St. Albans in 1290 to Eleanor, the devoted wife of Edward I, when her body rested there at one stage of its journey from Lincoln to London. At each of the twelve stages including St. Albans, an "Eleanor Cross" was erected later, the last being at Charing Cross, London.

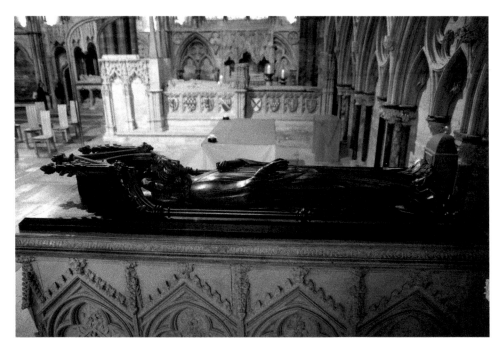

Queen Eleanor's tomb. (By kind permission of Lincoln Cathedral)

skirt. There were twelve crosses in all. Perhaps the most famous, a Victorian copy, stands at London's Charing Cross (Chère Reine).

On reaching London Edward decreed that two wax candles should burn eternally beside Eleanor's tomb in Westminster Abbey. The order was strictly followed for over 200 years.

Eleanor's visceral tomb in Lincoln Cathedral was replicated in 1890 on the 600th anniversary of her death and is sited near St Hugh's Shrine. On Eleanor's death Edward wrote, 'Living I loved her dearly and I shall never cease to love her in death.'

Quote

Victorian art critic John Ruskin (1819–1900) spoke of his admiration of Lincoln Cathedral's architecture: 'I have always held that the Cathedral of Lincoln is out and out the most precious piece of architecture in the British Isles and roughly speaking worth any two other cathedrals we have.'

Ruskin, writer, artist and art and architecture critic, took his first steps into the artistic world studying his father's collection of watercolours. His admiration of landscape painting in general, and J. M. W. Turner (1775–1851) in particular, knew no bounds. He considered it an honour to be living in the same age as the revered artist.

Ruskin published the first volume of *Modern Painters* in 1843 and the fifth and final volume seventeen years later, in 1860.

R

Red Arrows

The Red Arrows, the Royal Air Force Aerobatic Team, have been based at RAF Scampton, a few miles north of Lincoln city, since 2000 but, due to the planned closure of the base, will move to RAF Waddington, Lincolnshire.

The Red Arrows flew over central London at 10 a.m. on 8 May 2020 to mark VE Day, seventy-five years since the end of the Second World War in Europe. They have been performing thrilling aerobatics since 1965, flying nearly 5,000 displays in fifty-seven countries.

The team fly BAE Systems' Hawk T1, powered by a Rolls-Royce engine, reaching speeds of 645 mph. The pilots, engineers and essential support staff have all served on operational units.

The Red Arrows. (© By kind permission of defenceimagery.mod.uk)

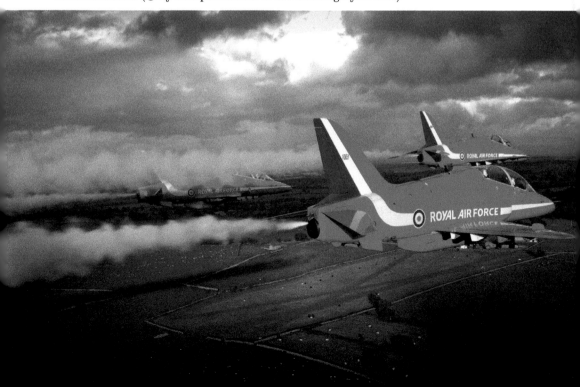

All eleven Red Arrow display pilots are from front-line RAF Squadrons. Prospective pilots need to be 'above average' in a flying role with a minimum of 1,500 flying hours. On completion of their three years with the team, pilots return to their RAF duties.

For over fifty years people around the world have flocked to witness the speed, agility and dexterity of the red jets skimming across the sky, leaving in their wake their trademark multi-coloured smoke trails long after they have disappeared from sight.

The Red Arrows are one of the world's leading aerobatic teams and inspire respect and admiration in the field of aviation worldwide. Some pilots join the RAF after watching displays as children and enjoying, among many other flying formations, the famous 'Diamond Nine'.

Robin Hood in Sherwood Forest

One of the earliest references to Robyn Hood and Robert the Robber appears in *The Vision of Piers Plowman*, a poem written by William Langland *c.* 1377. We also hear about Robin in *Accentuarius* by John of Garland, a precious manuscript held in Lincoln Cathedral's library. An unknown early fifteenth-century hand wrote:

Robyn Hod in Sherwood stood, hooded and hatted, hosed and shod.

It is believed to be the first written text linking Robin directly with Sherwood Forest (*see* Lincoln Green).

Sausage Festival

The Rotary Club of Lincoln Colonia sparked off an annual celebration of all things sausage nearly twenty years ago when eight stalls stood in Castle Square displaying their wares. Today over fifty sizzling stands fill the square and grounds with an appetising aroma, attracting around 10,000 visitors. You can sample a range of sausages from the renown Lincolnshire to lamb, venison, Cumberland, bratwurst and Polish varieties, all temptingly on sale.

Mr & Mrs Sausage with Juggling Jim. (Images by kind permission of Rotary Club of Lincoln Colonia and Lincoln Sausage Festival)

The Cosmic Sausages.

The festival is made special by Mr and Mrs Sausage posing for photos with visitors in their specially made costumes. Music is provided by the Cosmic Sausages who entertain in busking and music festivals worldwide. Fun on the day includes live cooking, children's circus skills, face painting, Juggling Jim and swing boats. You could even try your hand at hooking a sausage! Any profit is donated to local charities and good causes.

Steep Hill, the Strait and High Street

Aptly named Steep Hill offers you a thorough workout whilst tackling its picturesque cobbled streets! Allow plenty of time to peruse the diversity of its book, craft and gift shops and cafes and bars, all in the shadow of Lincoln's historic buildings. Note the Wig & Mitre public house, dating from the fourteenth century, next door to Brown's Restaurant and Pie Shop which once had a famous tenant in the shape of T. E. Lawrence (*see* Lawrence of Arabia). Nearby stands the twelfth-century stone Norman House, one of Steep Hill's oldest remaining domestic buildings.

Some medieval timber-framed buildings can still be seen on High Street and Steep Hill. You would be hard-pressed to miss the magnificent Grade II listed 'Cardinal's Hat', a three-storey half-timbered building dating from the late fifteenth century. It was the home of the Granthams, a family of wealthy wool merchants after whom the adjoining street is named. When the family moved away, the premises became an inn and in 1514 was named for King Henry VIII's Lord Chancellor, Cardinal

Right: The Strait.
(Photo Ray Wilkinson)

Below: Steep Hill.
(Photo Ray Wilkinson)

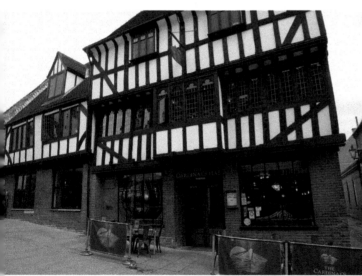

Above: Norman House.
(Photo Ray Wilkinson)

Left: The Cardinal's Hat.
(Photo Ray Wilkinson)

Thomas Wolsey, Bishop of Lincoln 1514–15. Over time the premises have been used as a fishmongers, a grocer's shop and bakery. It is now a lovely public house and restaurant.

The Jew's House dates from around 1150 with some original features preserved. It's thought that Jew's Court was once a twelfth-century synagogue. Chad Varah House, a Grade II listed building, stands in nearby Drury Lane. Dating from 1776, it was a hospital and then Lincoln Theological College. It's named for the Revd Edward Chad Varah CH, CBE, founder of the Samaritans, who studied at the college.

Leigh-Pemberton House, a half-timbered building dating from 1543, stands at the top on Castle Hill. The information board states that it stands over the old Roman Street, the Principalis, that ran north through the upper enclosure of Lindum Coloniae. It was once a merchant's house and then a bank, restored and presented in 1979 by the Chair of National Westminster Bank to the Dean and Chapter of Lincoln for the cathedral's use. In recognition of the gift, the building was named for the chairman of the bank, Sir Robert (Robin) Leigh-Pemberton. It is now the home of the Visitor Information Centre.

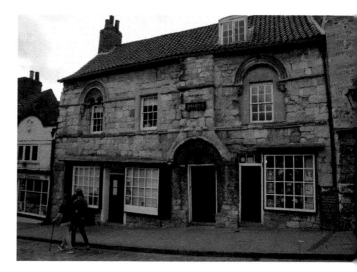

Right: Jews House.

Below: Leigh-Pemberton House.
(Photo Wendy Turner)

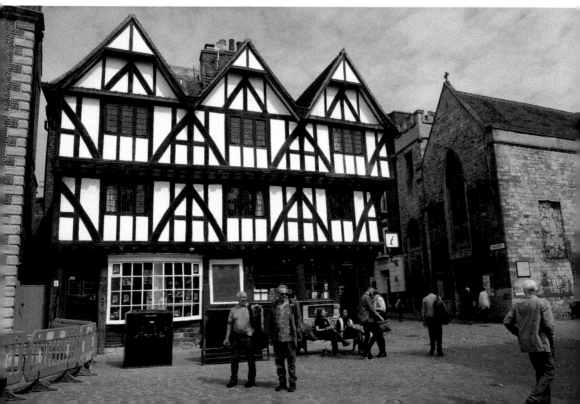

Stonebow and Guildhall

This impressive fifteenth-century stone arch in High Street gives visitors a solid welcome. It is built on the remnants of the old Roman South Gate. So unstable had the old arch become that a new gateway was ordered by the monarch, Richard II. The king also presented Lincoln with his sword in 1387, now displayed with many other treasures in the Guildhall. The sword is presented to every monarch visiting Lincoln in the hope that they will waive it away with the back of their hand, which recognises good governance of the city. Henry VIII was the first king to be offered the sword in this way. Happily, he complied!

The Stonebow and Guildhall was completed in 1520 and built for powerful medieval guilds that controlled the city. Richard I (Lionheart) granted permission for citizens of Lincoln to elect a mayor, which they first did in 1206, and in the 1300s Edward II made Lincoln one of eight Staple Towns through his 1326 charter. Lincoln is the third-oldest mayorality in the country behind London and Winchester.

Full council meetings are convened every eight weeks and have taken place for almost 600 years. A huge oak table was installed in the chamber in 1724, its width measuring just over two short sword lengths in order to discourage disputes that may have ended badly! Seats are arranged in a horseshoe accommodating the thirty-three councillors (from the eleven wards) with the portfolio holders sitting on either side of the mayor's chair.

Stonebow and Guildhall. (Photo Ray Wilkinson)

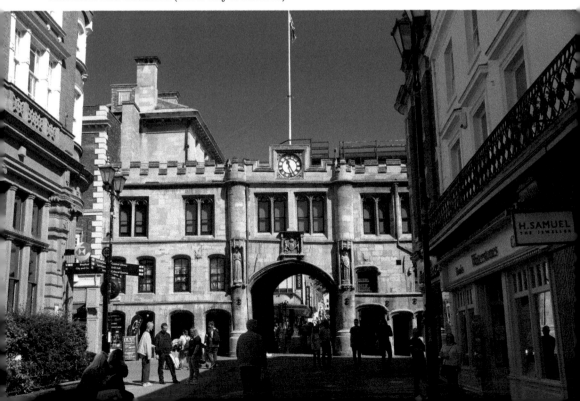

Right: Sword of Richard II. (By kind permission of City of Lincoln Council. Photo Ray Wilkinson)

Below: Oak table, Guildhall. (By kind permission of City of Lincoln Council. Photo Ray Wilkinson)

Ringing the Mote Bell. (By kind permission of City of Lincoln Council. Photo Ray Wilkinson)

The Mote Bell dates from 1371 and is the oldest meeting bell in use in England. It has chimed through the centuries summoning councillors to meetings. All Lincoln's bells rang out for the 2012 Olympics with the exception of the Guildhall's Mote Bell. Due to a last-minute mishap, the rope snapped at the volunteer bell-ringer's enthusiastic pull!

Among the regal portraits in the chamber is that of George III. He was treated in a private asylum in Lincolnshire run by the renowned physician and clergyman Dr Francis Willis, as portrayed in the 1994 film *The Madness of King George* with Nigel Hawthorne as the king. Another is of Queen Victoria who declined to leave the train at Lincoln. She was much put out at the antics of Col Charles de Laet Waldo Sibthorp, MP for Lincoln, who vowed to 'watch with a jealous eye the expenditure of the public money'. True to his word he lopped around £20,000 from Prince Albert's allowance, pronouncing him 'a foreigner!'

Col Sibthorp was something of a showman, as described by Charles Dickens in *Sketches by Boz* (Dickens' pseudonym):

> He is a ferocious looking gentleman, with a complexion almost as sallow as his linen, and whose huge black moustache would give him the appearance of a figure in a hairdresser's window ...

Col Sibthorp once alarmingly rode a carriage and four horses down Steep Hill. Railings are now installed to prevent any repeat! He is another of Lincoln's cherished, if somewhat eccentric, sons (*see* Level Crossing).

The Guildhall houses a collection of ancient charters, signed and sealed by monarchs through the ages. The oldest pre-dates Magna Carta, bearing the signature of Henry II in 1157. Other seals include those of Richard III and Henry VIII. Charles I presented Lincoln with its ceremonial mace, one of many treasures forming the city's Civic Insignia and displayed in the old debtors' prison in the Guildhall.

T

Tanks – For the Memory, Says the Kaiser!

Leonardo da Vinci sketched his idea for a moveable armoured car in 1487, adding that it was so secure that no company of soldiers could break through it, but the 'tank' only became a reality in the First World War. First Lord of the Admiralty Winston Churchill led the venture to aid trench warfare and in 1915 a contract was given to Fosters of Lincoln to design tanks for the British Army. At the time Fosters manufactured farm machinery and tractors but they came up with a prototype of the first combat tank, dubbed *Little Willie*, a reference to Kaiser Wilhelm II. While *Little Willie* demonstrated the possible successful use of a track-laying armoured vehicle, it was hampered by its 'tractor chassis', low speed and cramped interior. Building on results, a heavier version with a revolutionary track, greater protection and firepower was soon being manufactured. Known initially as *The Centipede* or *Mother*, it was widely christened *Big Willie*. *Big Willie* was better able to punch through barbed wire and cross wider trenches. 100 of the tanks were promptly ordered by the British Army in February 1916.

In 1918 King George V and Queen Mary visited Fosters where the King was delighted to ride in a tank at its place of origin. *Little Willie* now resides in the Tank Museum, Bovington, Dorset. Use of the word 'tank' sprang from the need to keep the ongoing work secret and promote the idea of a water tank instead.

Tank memorial bench,
Lincoln Arboretum.
(Photo Wendy Turner)

Mayor William Bell's silver model of 'Mother'. (By kind permission of City of Lincoln Council)

In their centenary year, 1956, Fosters presented a silver model of *Mother* to Mayor of Lincoln William Bell, who coincidentally had been an apprentice at Fosters and worked on the tank project.

Alfred Lord Tennyson (1809–92)

He stands, head slightly bowed, hat in hand. His wolfhound, Karenina, gazes up at him. He is intent on reading one of his poems:

> Little flower – but if I could understand
> What you are, root and all, and all in all,
> I should know what God and man is.

The words are inscribed on the base of Tennyson's statue in the grounds of Lincoln Cathedral. The writer G. K. Chesterton observed the strange disparity between Tennyson's huge bronze statue and the tiny flower that he struggles to understand.

Tennyson statue, Lincoln Cathedral. (Photo Ray Wilkinson)

Alfred was the third of eleven surviving children of George Clayton Tennyson, Rector of Somersby in the Lincolnshire Wolds, and his wife Elizabeth. The area was one of outstanding natural beauty and, although Alfred's childhood was marred by his father's depression, he took heart from the beauty of nature which inspired some of his most well-loved poems. At the age of seventeen he published his first volume, *Poems by Two Brothers*, and in 1832 another volume which included *The Lady of Shalott*. A line from Tennyson's *Ulysses* has found fame in many different locations worldwide:

To strive, to seek, to find and not to yield

It was quoted by Senator Ted Kennedy when he lost the 1980 Democratic Presidential nomination and by Judi Dench as 'M' in the James Bond film *Skyfall*. The quote was also permanently inscribed on a wall of the Olympic Village for the 2012 Olympic Games in London.

Alfred entered Trinity College Cambridge where he met Arthur Hallam, son of historian, author and poet Henry Hallam. Their friendship came to an abrupt end when Arthur accompanied his father on a trip to Vienna, suffered a cerebral haemorrhage and died at the age of twenty-two. Alfred grieved for his friend, eventually producing his poem *In Memoriam A. H. H.* containing the lines:

'Tis better to have loved and lost
Than never to have loved at all.

On the death of Albert in 1861, Queen Victoria is quoted as saying that next to the Bible, *In Memoriam* was her comfort.

Alfred married Emily Sellwood, his sister-in-law's sister, and fondly named one of his two sons 'Hallam'. He became Poet Laureate in 1850 on the death of Wordsworth, a post he held for many years during the reign of Queen Victoria. He also became Alfred Tennyson, 1st Baron Tennyson FRS.

Tennyson died at the age of eighty-three and was buried in Westminster Abbey. Shortly after his death, his friend George Frederick Watts began work on a memorial statue commissioned by Lincolnshire. Watts himself was eighty-six on its completion but sadly died in 1904, a year before its unveiling.

You can visit Tennyson's birthplace at Somersby House, walk the circular paths following in his footsteps and rest by the stream that inspired his poem *The Brook*:

I chatter, chatter, as I flow
To join the brimming river
For men may come and men may go
But I go on forever

Tennyson plaque, Lincoln Cathedral. (Photo Wendy Turner)

The last two lines of the poem and other quotes from Tennyson can be seen on artwork commemorating his 200th anniversary on the Sustrans Water Rail Way which runs along the route of the former Lincoln to Boston Railway (*see* Water Rail Way).

The Tennyson Research Centre, housed at Lincolnshire Archives, contains the world's most significant collection on Alfred Lord Tennyson which includes his personal libraries together with manuscripts, letters, photographs and some of his personal belongings. The University of Lincoln has a building named for him.

Alfred Lord Tennyson was the most famous of the Victorian poets and the first ever poet to become a Lord. He is our most frequently quoted writer after Shakespeare.

Trondheim Pillars of Lincoln Cathedral

Two Trondheim pillars can be found in Lincoln Cathedral. The style, with characteristic curling leaves, is unique in Britain and is only found elsewhere in Nidaros Cathedral, Trondheim, in Norway. Trade flourished between Lincoln and Nidaros in medieval times and included salt, malt, honey, rope, cloth, hides and furs. Hawks and falcons were in great demand in England, especially the sought-after Gyrfalcon, a highly prized gift, almost as valuable as currency in its time.

Trondheim Pillar. (By kind permission of Lincoln Cathedral. Photo Ray Wilkinson)

U

University of Lincoln

The University of Lincoln has over 15,500 students studying in its modern buildings near the picturesque Brayford Pool. The Academic School comprises the four colleges of Arts, Science, Social Science and the Lincoln International Business School, together with its new Medical School.

The university has strong partnerships and local links, from working with Siemens and establishing the first dedicated new School of Engineering in the UK for over twenty years, to a study of Lincoln's cherished swan population to better understand their health and habits.

Students also enjoy live music and entertainment on campus in the renovated Engine Shed and theatre and creative arts in the Lincoln Performing Arts Centre (LPAC).

In 2020 the Guardian University Guide ranked University of Lincoln among the top twenty UK universities. It holds a Gold award in the national Teaching Excellence Framework (TEF) and is one of the top ten UK universities recognised for reducing its carbon footprint and promoting sustainability. The annual graduation ceremony is held in Lincoln Cathedral, when around 3,000 students celebrate their achievements.

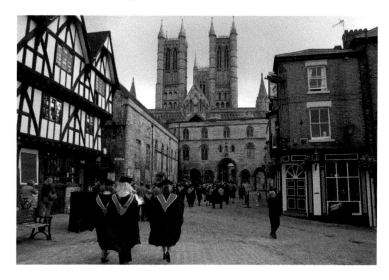

Graduation Day in Lincoln city. (© Photos by kind permission of the University of Lincoln and Electric Egg)

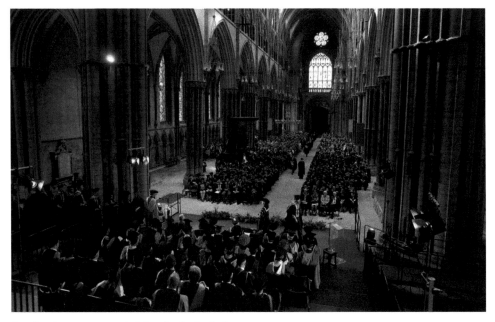

Graduation ceremony in Lincoln Cathedral.

Usher Gallery

The Usher Gallery stands in Temple Gardens, a haven of architectural and horticultural beauty, once part of the lower Roman city of Lindum Colonia. The gardens were named when Lincoln solicitor Joseph Moore built his 'Greek temple', a copy of the Greek Choragic Monument of Thrasyllus, in the gardens. Such monuments celebrated athletic or choral achievements in ancient Greece: Moore's temple housed equipment for a water feature. His vision was to create a leisure and pleasure area in Lincoln displaying artwork and antiques with exhibitions and music. On its completion in 1824 visitors were charged an annual fee of ten shillings (50p) to enjoy its ambience. The gardens were reopened in 1927 by the Prince of Wales, the future King Edward VIII who abdicated in 1936 to marry American divorcee Wallis Simpson.

The Usher Gallery was designed by Sir Reginald Blomfield RA (1856–1942) but its story goes back to 1837 when James Usher started up his 'timely' watchmaking and jewellery business in Lincoln. Lacking start-up funds, James displayed his personal watch in the shop window.

James' son, James Ward Usher, joined the business which became 'Usher and Son'. His passion for beautiful and intricate objects blossomed along with his ever-growing collection of clocks, watches, ceramics, silver, miniatures and porcelain. James was also a shrewd businessman. He became the main supplier of trophies and ceremonial pieces and for a while secured the sole right to use the image of Lincoln's famous Imp on his jewellery and other goods. So notable did he become that letters addressed to

the 'silversmith' with a drawing of the Lincoln Imp would reach him. You can see his Lincoln Imp brooch in the Usher Gallery together with his fabulous collection that he bequeathed to the City of Lincoln with generous funds to build a gallery to house them. James never married but spent his time travelling and searching for the precious artefacts he loved. He was appointed Sheriff of Lincoln in 1916 and died at the age of seventy-six in 1921.

The Usher Gallery is a wonderland of fine and decorative art and horology with an extensive collection of paintings by artists both ancient and modern.

James Ward Usher is another of Lincoln's best-loved sons.

Above: Usher Gallery.
(Photo Ray Wilkinson)

Right: 'A Mighty Blow for Freedom' in grounds of the Usher Gallery.
(Michael Sandle)

Victoria Cross – John Hannah VC (1921–47) and the Hannah Rose

Born and educated in Scotland, John Hannah started his career as a shoe salesman but in 1939 he enlisted in the RAF and trained as a wireless operator/air gunner. After a brief spell at the Yorkshire-based 106 Squadron operating Handley Page Hampden bombers, he arrived at RAF Scampton, Lincolnshire, and joined 83 Squadron carrying out day and night operations on German-held ports in France and Belgium.

On the night of 15 September 1940 the squadron took part in a raid on enemy barges in Antwerp planned to be used to invade Britain, but Hannah's aircraft suffered a direct hit which erupted inside the bomb bay. A fierce fire broke out and, after using up the two extinguishers on board, he fought back the flames with a logbook and then

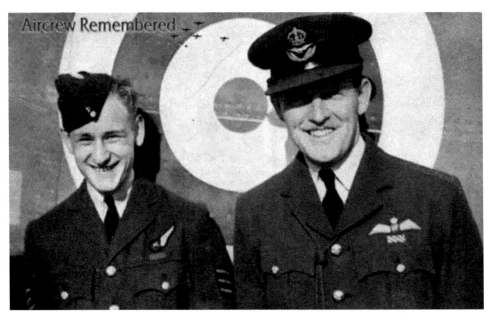

John Hannah VC (on left). (© By kind permission of Aircrew Remembered)

his bare hands. Ammunition exploded all around and the ravaged bomb bay turned into a blazing inferno. The extreme heat almost blinded him but he found some relief by using his oxygen supply. After crawling around the aircraft, he discovered that the navigator had had no choice but to bail out and Hannah handed his logbook and maps to the pilot. Although terribly injured, his actions enabled the pilot to fly the ravaged aircraft safely back.

John Hannah learned of his award of VC, the UK's highest award for gallantry in the face of the enemy, whilst in Rauceby Hospital, Lincolnshire. On recovery, he was accompanied to Buckingham Palace by Pilot Officer C. A. Connor, DFC. Tragically Connor was killed in action less than two months later.

Hannah never returned to operational flying but took up an instructor role and was promoted to Flight Sergeant. He met and married Janet Beaver and they had three daughters. Sadly, he contracted tuberculosis and died in June 1947, at the age of twenty-five.

John Hannah is another of Lincoln's beloved sons. The press dubbed him 'the eighteen-year-old lad who saved his plane and won the VC'. After his death his wife presented his medals to 83 Squadron. They are now kept in the RAF Museum, Hendon.

John Hannah's memory lives on in the beautiful hybrid 'Hannah Rose', created in his memory and honour, whose colour perfectly matches that of the Victoria Cross ribbon.

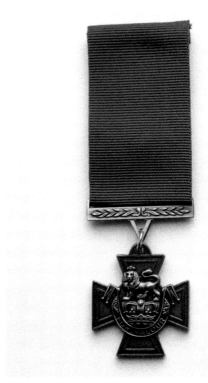

Victoria Cross. (Photo Wendy Turner)

Waterfront and River Witham

You can almost feel the city's lifeblood bubbling and flowing to the rhythm of the Witham along Lincoln's lively Brayford Waterfront. A medley of restaurants, bars, hotels, music and entertainment venues line the waterfront amid eye-catching artwork and engineering projects, with spectacular views across the River Witham to the university's modern campus. This was the site of Lincoln's first known settlement dating to around the first century BC and known as 'Lindon' from Lindo – 'the Pool'.

Yet the area around the waterfront has a long and embattled history. It has been invaded by a multitude of cultures and armies from Roman times to the Norman invasion of

Waterfront. (Photo Wendy Turner)

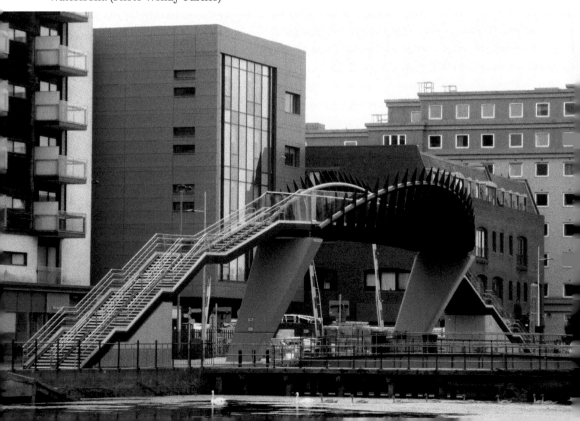

Above: Narrowboat.
(Photo Ray Wilkinson)

Right: Marina.
(Photo Ray Wilkinson)

William the Conqueror. Countless citizens and soldiers on losing sides who fled the castle and stormed down Steep Hill in a bid for freedom, drowned in the Witham.

An area rich in archaeology, remains of ancient houses and pottery have been found during excavations, some from marshland reclaimed by the Romans, now the Waterside Shopping Centre. One spectacular find was the huge Iron Age Witham Shield discovered during the dredging of the Witham at Washingborough in 1826. Dating to the third century BC, the bronze facing of the shield is elaborately crafted using La Tène (Celt) decoration, with intricate swirling patterns and animal head designs. The shield is on display in the British Museum.

The River Witham has been a means of transportation of goods from Roman times. In 1981 an Iron Age timber causeway was discovered during works undertaken by the

Bridge at Waterfront. (Photo Wendy Turner)

Environment Agency at Fiskerton, a few miles east of Lincoln. Iron Age weapons came to light as well as a complete log boat hewn from a single tree trunk. The Fiskerton log boat is around 2,500 years old and can be seen in The Collection.

A boat trip around the Brayford Pool includes a potted history of Lincoln with impressive views of the Empowerment statue, High Bridge and the Glory Hole and the modern buildings of the University of Lincoln. At the end of your trip, you may be able to answer the questions inscribed on the bridge: 'Where are you going?' 'Where have you been?'

Water Rail Way

For a real breath of fresh Lincolnshire air, you could take the Water Rail Way that runs alongside the former Lincoln to Boston Railway. Walking or cycling, you can follow the path to its end or turn aside on access points to visit pretty towns and villages along the way.

The route follows the River Witham from Lincoln city and opens out onto a level path with little traffic through a panorama of fenland countryside. Dedicated artistic viewing platforms along the way offer more spectacular views, and the commissioned Sculpture Trail enlivens your journey with artworks to commemorate the 200th anniversary of local poet Alfred Lord Tennyson and artistic works reflecting nature and local animal breeds (*see* Alfred Lord Tennyson).

The Water Rail Way is a wildlife corridor that covers around 33 miles and is part of the National Cycle Network, cared for by Sustrans.

Above: Pike, Water Rail Way. (© By kind permission of Nigel Sardeson)

Right: On the Water Rail Way. (Photo Ray Wilkinson)

'Lincoln Reds', Water Rail Way. (© By kind permission of Sally Matthews)

Xmas Market

Around 300 stalls combine to ensure that Lincoln's acclaimed Xmas Market remains one of the highlights of the year. One of the largest in Europe, it attracts over 250,000 people throughout the four-day celebration and offers a dazzling array of gifts and festive food and drink from near and far. Musicians, artists, fun and entertainment are never far away and local art and craft can be found in the Artists' Christmas village.

The Xmas Market springs into life in Lincoln's historic Cathedral Quarter. It is impressively illuminated at night and spreads out onto nearby streets and open spaces.

X-ray Scanner

A new X-ray body scanner will operate in HMP Lincoln, one of sixteen being installed in prisons across England and Wales. The scanners detect items smuggled inside the body and produce instant images. They are part of an overall Ministry of Justice investment on scanners nationally to transform prisons and make detection easier.

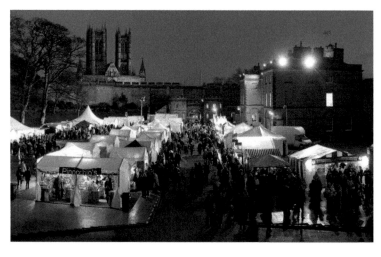

Xmas market. (By kind permission of Visit Lincoln)

Y

Yellowbellies

It's said that a true 'Lincolnite' is proud to be a 'Yellowbelly'. There are a variety of explanations for this droll title.

The former Victorian barracks, now the Museum of Lincolnshire Life, was once home to the Royal North Lincoln Militia. In conflicts, officers wore vivid yellow waistcoats so as to be more easily identified by their men. They were labelled 'yellow-bellies'.

Mail coaches first came into being in the 1780s and were adopted by the Post Office. The guard on board wore a formal uniform and was armed with pistols. One of his duties was to record arrival and departure times on journeys while sounding his post horn to alert people that galloping horses were coming through. The Lincoln mail coach was said to sport bright yellow paint on its underside and people awaiting their mail would cheer on the 'Lincolnshire Yellowbelly!' If the mail coach was not due to stop, the guard and the letter receiver would fling bags of letters at each other.

It's likely that Lincoln's traditional sheep, the beautiful Lincoln Longwool, wandered through fields of mustard plants picking up pollen which turned their long thick coats bright yellow.

Local women traders were reputed to have worn leather aprons with pockets for copper, silver and gold coins. If they had a 'yellow belly' at close of day, it was a sign of good trading.

Lincoln Longwool sheep.
(© By kind permission of Louise Fairburn LLSBA)

Zincography

Zincography is a planographic process (printing from a flat or smooth surface) using zinc plates. The process has been used by artists and illustrators through the centuries. The image here is a scarce map produced by Ordnance Survey for the Boundary Commission in 1885.

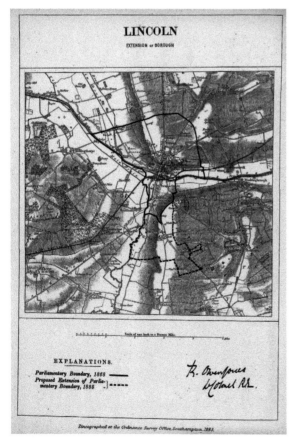

Report of the Boundary Commission, 1885. Lincoln antique map. (© By kind permission of Frontispiece Ltd)

Lincolnshire Ordnance Survey antique map, 1885. (© By kind permission of Frontispiece Ltd)

Zulu!

The phrase brings to mind Michael Caine as Lt Gonville Bromhead and Stanley Baker as John Chard, battling against thousands of Zulu warriors at Rorke's Drift in the 1964 film *Zulu*. The line came from the lips of Colour Sergeant Frank Bourne OBE, DCM played by Nigel Green. The real Bourne was only twenty-four. He was the youngest NCO of the rank in the British Army and widely known by his men as 'the kid'.

It was filmed in South Africa where the mission station, the site of the battle, was recreated, and tells of the relentless attacks of 4,000 Zulu warriors on 150 British soldiers who were their next target after the massacre of around 1,800 British soldiers earlier that day at Isandlwana.

The battle at Rorke's Drift started in late afternoon and continued into the night. Thousands of brave Zulus perished but, as exhaustion crept in and ammunition ran out, the British faced almost certain death. At a crucial point the Zulus retreated. It's thought that had they attacked once more they would probably have succeeded.

One enduring moment of the film was when Ivor Emmanuel, as Private Owen, led a rousing chorus of *Men of Harlech* to raise the spirits of the British and counter the chilling chant of the Zulu warriors as they advanced to the deafening rhythmic beating of their assegai spears on their shields.

Lt Bromhead and Engineer John Chard were both awarded the Victoria Cross. Eleven VCs were awarded in total after Rorke's Drift, more than any ever awarded for a single battle.

Lieutenant Bromhead's country home lies in North Kesteven, a few miles south-west of Lincoln. The conflict is commemorated still by descendants on both sides.

Acknowledgements

With special thanks for their assistance:

City of Lincoln Council
Lincoln Castle
Lincoln Cathedral
Stonebow and Guildhall
Ray Wilkinson

The author and publisher would like to thank the following people/organisations for permission to use copyright material in this book:

Aircrew Remembered
City of Lincoln Council
William Fairbank
Louise Fairburn LLSBA
Lincoln BIG
Lincoln Cathedral
Lincolnshire Embroiderers' Guild
Andrew Marriner, Susan Harries and Meirion Harries
Sally Matthews
Rotary Club of Lincoln Colonia and Lincoln Sausage Festival
Ruddocks Publishing Lincoln
Nigel Sardeson
Peter Skelson, Lincoln RSPB
Stonebow and Guildhall
Mr. P. Tumber
University of Lincoln
www.defenceimagery.mod.uk
www.mapsandantiqueprints.com
www.visitlincoln.com

Thanks also to:

Airfield Trail: North Kesteven. RAF Cranwell.
Extensive search has been made for the author of the 1916 introductory quote.

Stephen Broadbent
Judith Foster
International Bomber Command Centre (IBCC)
LincolnLive
Lincolnshire Archives
Yvonne Moxley
Roger Paine
RAF Coningsby
The Lincolnite
Shutteworth Collection
Kevin Winter. National Civil War Centre, Newark

www.api.parliament.uk/historic-hansard
www.capitalpunishmentuk.org
www.emreg.org.uk
www.lincoln.gov.uk
www.lincstothepast.com
www.raf.mod.uk
www.stokescoffee.com
www.vconline.org.uk
www.commons.wikimedia.org

and numerous others who have helped along the way.

Bibliography

The following books have been invaluable resources:

Clark, David, *It happened in Lincolnshire* (Merlin Unwin Books, 2016)

Kesson, H. J. (Ursus) 1904, *The Legend of the Lincoln Imp:* (J. W. Ruddock & Sons Ltd)

Lincoln: A Walking Guide (Tucann Ltd, 2014)

Lincoln Castle: (Scala Arts & Heritage Publishers Ltd, 2015)

Lincoln Cathedral: The Story so Far (Lincoln Minster Shops Ltd)

Pitkin City Guides: Lincoln (Pitkin Publishing, The History Press)

Wade, Stephen, *The A-Z of Curious Lincolnshire* (The History Press, 2011)

Wood, Lucy, *The Little Book of Lincolnshire* (The History Press, 2016)

About the Author

Wendy Turner lives in Hertfordshire and has been writing articles for many years for a variety of magazines, including *This England*, *Evergreen*, *People's Friend*, *The Countryman* and *Veracity*, the online magazine of Verulam Writers, St Albans, Herts. *A–Z of Lincoln* is her second in the series, the first being *A–Z of St Albans*. She is a keen photographer (point and shoot!) and is delighted to have found such wonderful treasures in the 'Places, People and History' of Lincoln.